WITNEY

THROUGH TIME

Stanley C. Jenkins

AMBERLEY PUBLISHING

Acknowledgements

Thanks are due to Michael French, Tony Florey and Graham Kew for help with the supply of photographs for this book. Other images were obtained from the Witney & District Museum, and from the author's own collection.

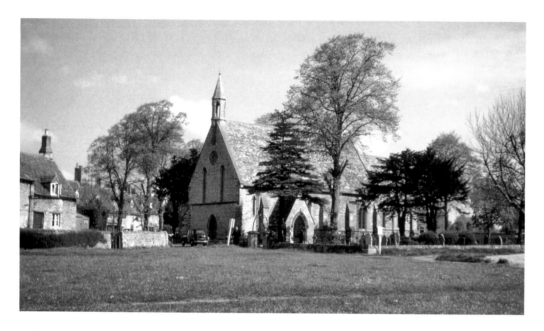

Holy Trinity Church, Woodgreen, c. 1962

First published 2012

Amberley Publishing
The Hill, Stroud
Gloucestershire, GL5 4EP

www.amberley-books.com

Copyright © Stanley C. Jenkins, 2012

The right of Stanley C. Jenkins to be identified as the Author of this work has been asserted in accordance with the Copyrights, Designs and Patents Act 1988.

ISBN 978 1 4456 0949 2

British Library Cataloguing in Publication Data.
A catalogue record for this book is available from the British Library.

Typeset in 9.5pt on 12pt Celeste.
Typesetting by Amberley Publishing.
Printed in the UK.

Introduction

Witney is a small town on the edge of the Cotswolds. The original settlement grew up in a marshy area between divergent channels of the River Windrush – the first primitive village being sited on a low hillock known as 'Witta's Island' (or perhaps 'White Island'). Witney is first mentioned by name in Anglo-Saxon charters of 969 and 1044, which tell us that the manorial estate was owned by the Bishop of Winchester.

The *Domesday Book* suggests that, in 1086, Witney was a village of 56 households with a total population of perhaps 250. The manor contained 'two mills rendering 32s 6d', and there was a further mill in the adjacent manor of Cogges. However, it is likely that these mills would have been used for grinding corn, and there is no evidence that a specialised woollen industry had developed by early Norman times.

As Lords of the Manor, successive Bishops of Winchester were able to influence the development of Witney in a variety of ways, and in the early thirteenth century a spacious 'new town' was laid out to the east of the earlier village. The medieval new town was aligned from north to south, with long burgage plots extending to the east and west of a wide marketing area, which later became Church Green, Market Square and High Street. Smaller building plots were created on each side of Corn Street, which diverged westwards from Market Square. A further pathway, which later became Crown Lane, ran east towards the village of Cogges and a market cross was erected at the junction of these streets and tracks. At its north end, High Street merged into the present Bridge Street, Newland and West End. The whole settlement was surrounded by a drainage ditch known as 'Emma's Dyke', and in places, the newly-created burgage plots were artificially raised above water level.

By the end of the Middle Ages, Witney had grown into a prosperous market town with a population of around 1,000 and a slowly-developing blanket industry. Weaving was carried out in Witney, while domestic spinning was undertaken over a wide area of the Cotswolds. It is likely that Witney became a cloth-making centre as weavers sought to escape the restrictive guild regulations in old-established 'industrial' towns such as Coventry. At the same time, the fast-flowing River Windrush was ideal for turning water wheels and scouring broadcloth.

Witney had a population of about 1,800 at the time of the Civil War, when the town suffered at the hands of marauding Royalists. The local population was strongly Protestant and when, at the Restoration, the more extreme Puritans excluded themselves from the Church of England, Witney became a centre of non-conformity, with Quaker, Baptist and Independent congregations. In the eighteenth century, John Wesley paid many visits to the town and Methodism eventually became the dominant form of local dissent.

Meanwhile, the blanket trade had gone from strength to strength, and by 1800, five mills were in operation in and around the town. The blanket industry was dominated by non-conformists and most were related to each other by birth or marriage. In 1711, the weavers obtained a charter of incorporation from Queen Anne in order that they could legally organise themselves into a

guild or company for the better regulation of the industry. In 1721, the Company of Weavers erected a Baroque 'Blanket Hall' in Witney High Street as their headquarters and this building remained in use until the 1840s.

By 1914, there were six mills in operation, divided between four main blanket making firms: Charles Early & Co., William Smith & Co., James Marriott & Sons and Messrs Pritchett & Webley. The latter firm also had interests in a glove factory in Newland, but when Pritchett & Webley failed, the gloving business carried on as a separate concern. In 1933, a Yorkshire firm, James Walker & Son of Mirfield, opened another mill in the town, bringing welcome new employment to the town when other areas were suffering from the effects of the Great Depression.

In 1951, Witney became a centre of light engineering when Smith's Industries established a large factory on the site of Witney Aerodrome, to the west of the town. The presence of Smith's and other industrial concerns ensured that, by the 1950s, Witney was no longer entirely dependent upon the woollen industry. Nevertheless, the town remained a famous blanket-manufacturing centre until 2002, when the very last mill was closed.

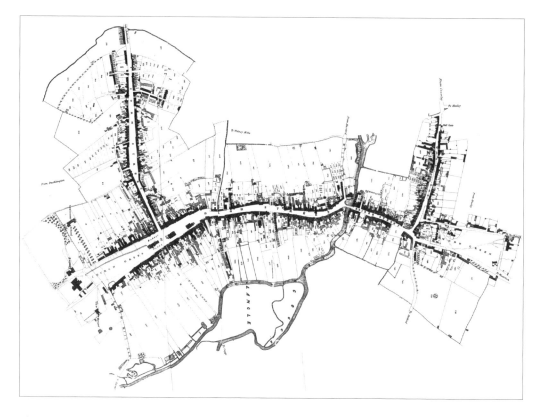

The Witney Tithe Map
The Witney Tithe Award Map shows the layout of the town c. 1840, with its long axis extending from Church Leys in the south to Wood Green in the north. Corn Street and West End can be seen diverging to the west, though it should be noted that Newland, which was in the contiguous parish of Cogges, is not shown.

4

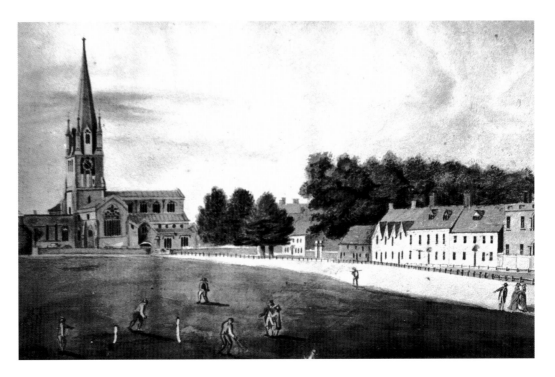

St Mary's Church

St Mary's Parish Church is a cruciform structure measuring approximately 130 feet from north to south and 130 feet from east to west, while the tower has a height of 156 feet. Blocked round-headed windows in the nave suggest that the first church, which was probably erected during the eleventh century, consisted of a nave and chancel, while the north aisle, with its Norman doorway, was a twelfth-century addition. The church was enlarged during the thirteenth century, when it acquired transepts and a new chancel.

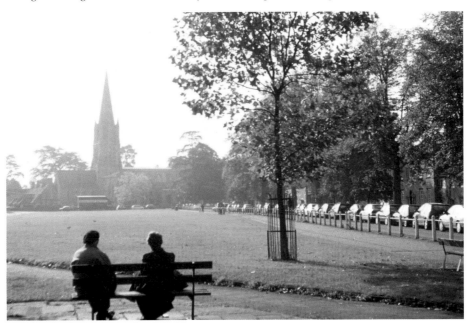

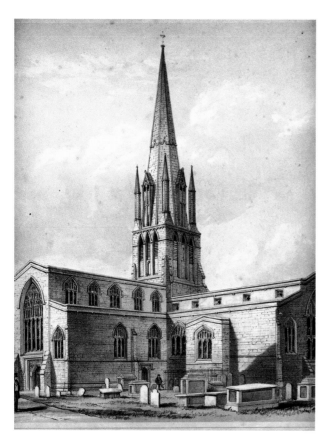

St Mary's Church
Witney's impressive Parish church, as shown in a Victorian print by C. Moody of High Holborn *c.* 1850. The lower picture shows details of the chancel and north transept – the blocked archway on the left formerly gave access to a Chantry chapel, which was converted into a sexton's house after the Reformation.

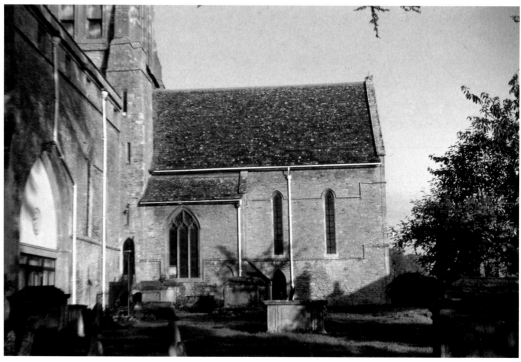

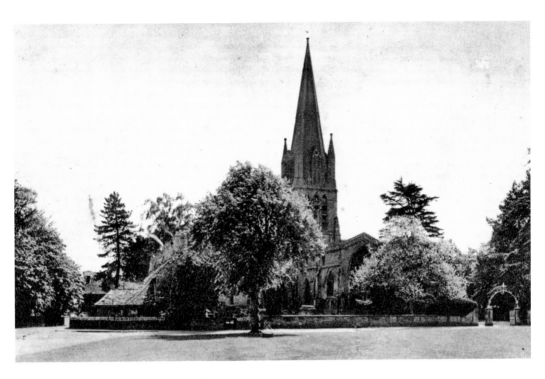

St Mary's Church From Church Green

St Mary's Parish Church as seen from Church Green in a 1920s postcard view (above) and as it appears today (below), showing that very little has changed in this part of Witney. It is assumed that the central tower, with its magnificent Early English spire, was added during the thirteenth century, although the ringing chamber within the tower contains an unusual mural passage, which is pierced by Saxon-style triangular-headed openings – a possible indication of greater antiquity.

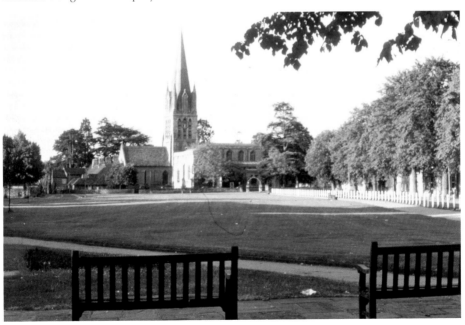

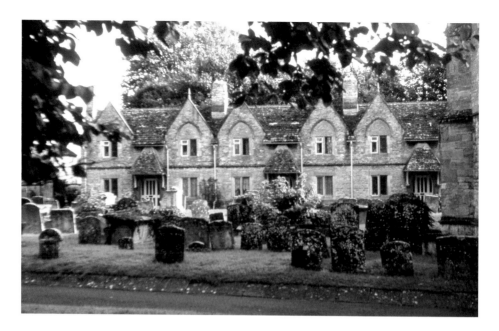

St Mary's Church & Holloway's Almshouses

St Mary's Church as depicted in a drawing by the Witney architect William Wilkinson (1819–1901). Witney has three rows of almshouses, including those in the churchyard (above), which were bequeathed to the town by John Holloway in 1724, and reconstructed by Wilkinson in 1868. The Victorian print (below) shows the church prior to restoration by the Diocesan architect G. E. Street, who reconstructed the chancel with a new roof as part of a series of changes carried out in 1865–69.

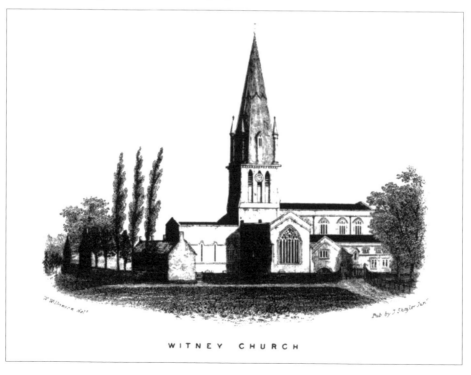

WITNEY CHURCH

Mount House & 'Witney Castle'

Around fifty years after the Norman Conquest, the Bishop of Winchester erected a stone-built manor house at Witney in convenient proximity to the parish church. A later bishop, Henry de Blois (*c.* 1096-1171), transformed this already-substantial house into a walled and moated castle, with a gatehouse and characteristic Norman 'tower-keep' – the fortifications being added during the period of civil war between King Stephen and the Empress Matilda.

The civil war ended in 1153 and, thereafter, the manor house reverted to its original role as the headquarters of a manorial estate – although, as late as the Victorian period, local historians such as W. G. Monk referred to the half-ruinous building as 'Witney Castle'. In later years, the site was occupied by an Edwardian villa known as 'Mount House', which is shown in the lower illustration.

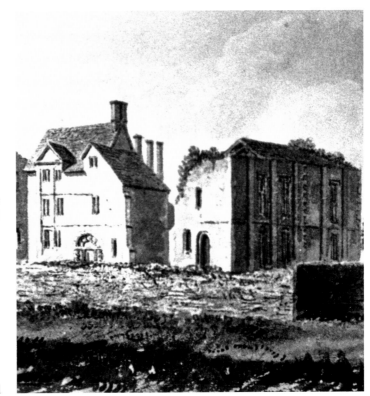

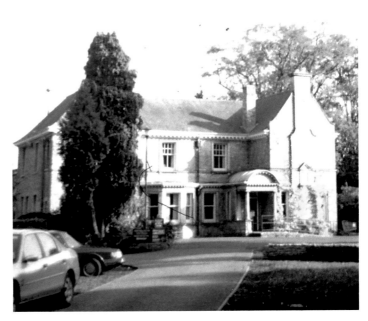

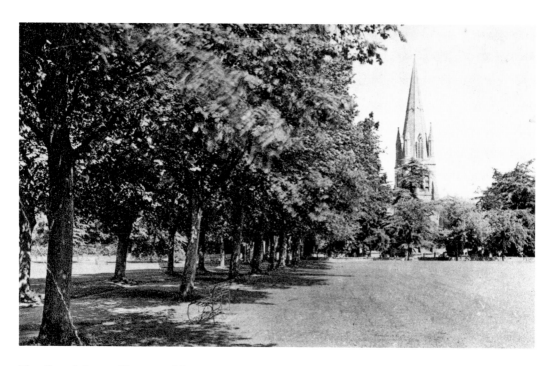

The Church Leys – The East Side

At the end of the Second World War, a war memorial committee had wanted to commemorate Witney's fallen heroes by erecting a cottage hospital. The committee hoped to raise £12,000, but the target figure was not reached. As an alternative, it was decided that Church Leys recreation ground would be purchased from the Church of England for the sum of £1,027 2s 0d, so that it would become a memorial to those who had died in the 1914–18 conflict.

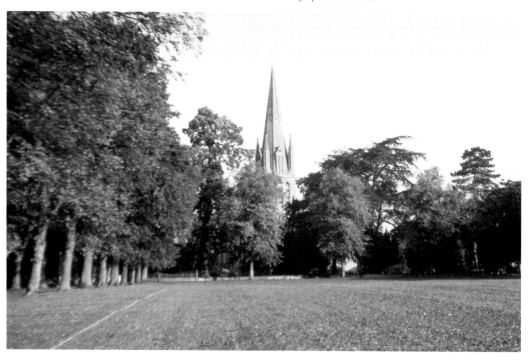

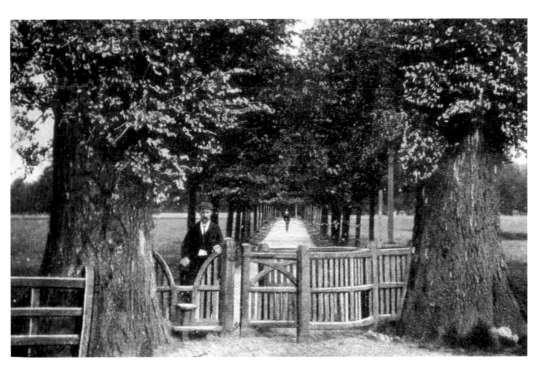

The Church Leys – Batt's Walk

Witney's first railway station, on the east side of the Leys, had been opened in 1861, but in 1873 a new passenger station was brought into use on a more southerly site that was somewhat further away from the town. On 5 December 1872 the *Witney Express* reported that 'a new footpath had been laid across the Leys', with young trees planted on either side 'following a suggestion by Dr Batt', which thereby created a direct link between the new station and the town centre, and obviated a lengthy detour that would otherwise have been necessary around the perimeter of the Leys.

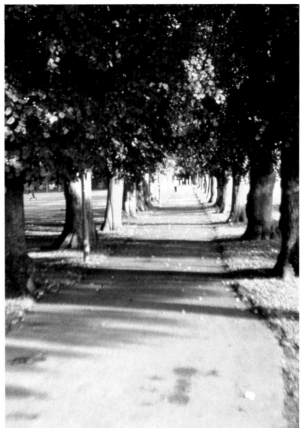

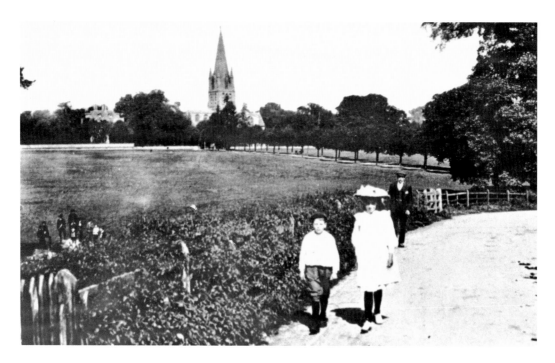

The Church Leys – The West Side

An Edwardian view, photographed from the approach ramp to the railway bridge *c.* 1910, showing the western side of the Leys, with the church tower clearly visible in the background. The lower view, which was taken from the bridge before its removal, shows the children's playground that was provided at the south-west corner of the Leys.

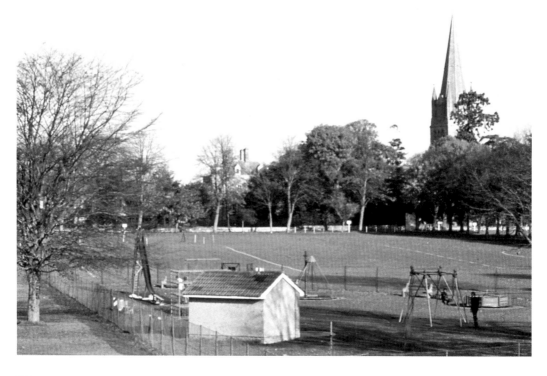

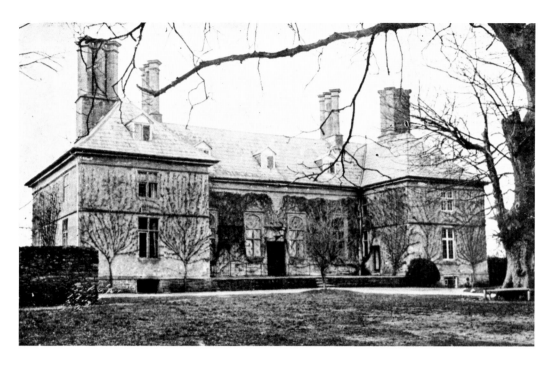

Witney Grammar School

Witney Grammar School was founded in 1660 by Henry Box (1585–1662), a member of a prominent Witney family who had made his fortune as a businessman in the City of London and wished to endow a grammar school in his native town. The 'very fair schoolhouse', which was under construction by 1660 (or possibly slightly earlier), is one of the finest vernacular buildings in Witney; its distinctive yet dignified appearance reflecting the architectural taste of the Commonwealth period.

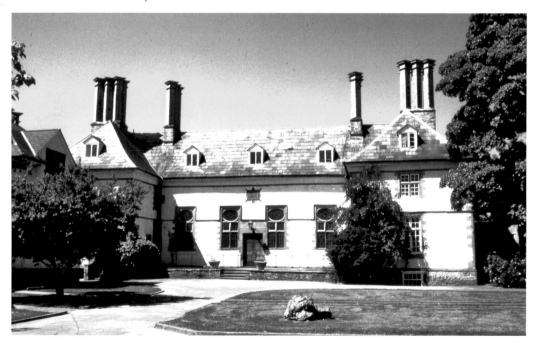

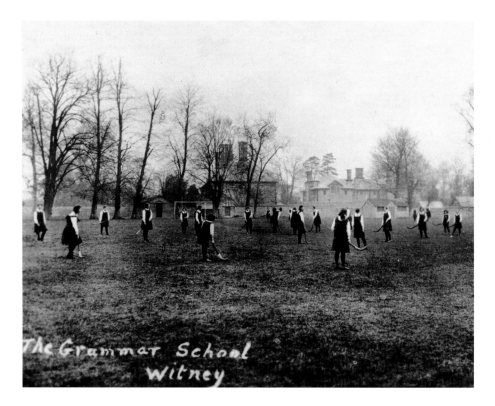

Witney Grammar School

A 1920s postcard view of the grammar school playing field, with a girls' hockey game in progress. Girls were first admitted in 1904 and by 1911, the school had around ninety pupils. In 1939, the school opted for County Council control, while in 1969 this historic school became a non-selective comprehensive known as 'The Henry Box School'. The view from the playing field (below) has since been transformed by the demolition of the War Memorial Pavilion.

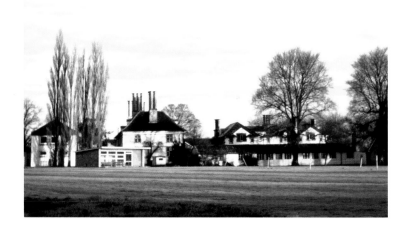

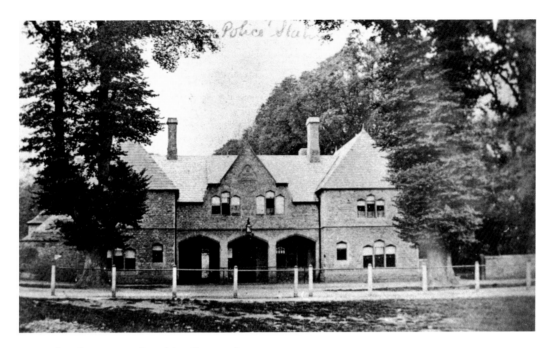

Church Green – The Old Police Station

Witney's first purpose-built police station was designed by William Wilkinson and erected in 1860, the contractor being Malachi Bartlett (1802–75) of Witney. The new building, which replaced an earlier police 'lock-up' at 33 Market Square, incorporated residential accommodation for an inspector and sergeant, as well as offices, cells, a court room and other facilities. The building was later used by the county's educational authorities, following the opening of a new police station in Welch Way.

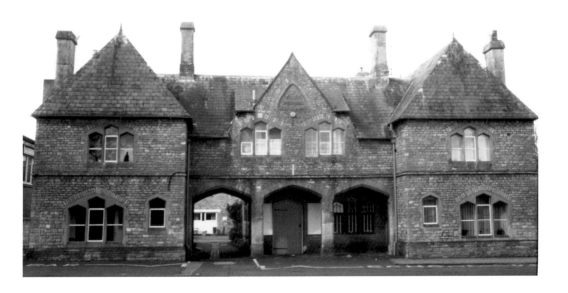

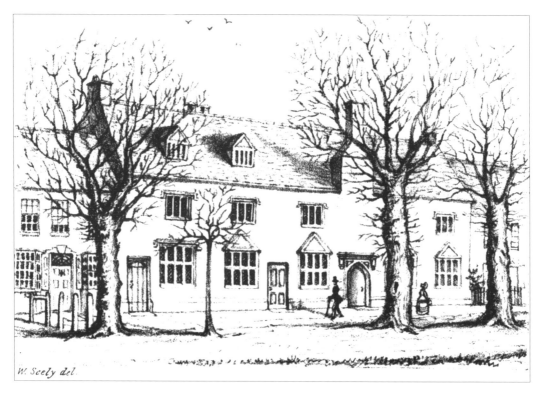

W. Seely del.

Church Green – The Hermitage

Nos. 3–5, 'The Hermitage', a Tudor building on the east side of Church Green, is clearly one of the oldest domestic buildings in Witney, its ornate façade being dated '1564'. When first constructed, the building would have contained a centrally-placed hall, but this large room was later subdivided. The Hermitage is said to have been used as plague retreat by the Fellows of Merton College in 1665, while in 1916 it housed a 'Young Men's Social Club'.

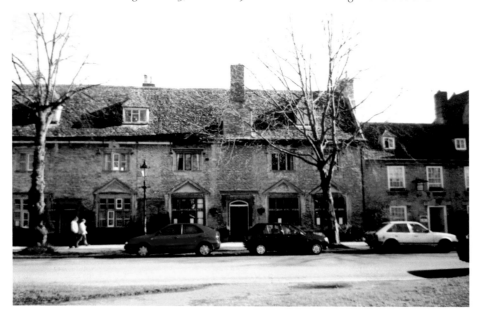

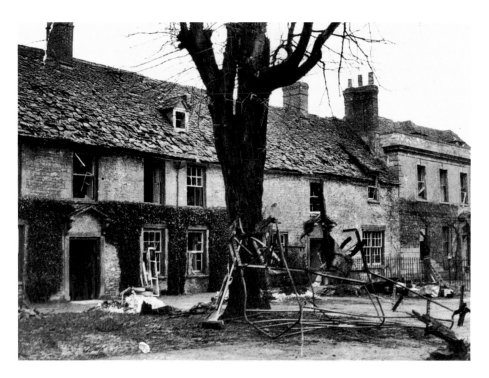

Church Green – Wartime Bomb Damage

On the night of 21 November 1940, Witney was hit by two bombs, one of which landed on Church Green while the other exploded behind the Eagle Brewery. The bombs caused blast damage to the grammar school and many houses on Church Green, while falling glass from the roof of the weaving sheds at nearby Mount Mill severed the 'warps', and production was halted while the 'chains' of warp were replaced. The damaged houses were soon repaired (below).

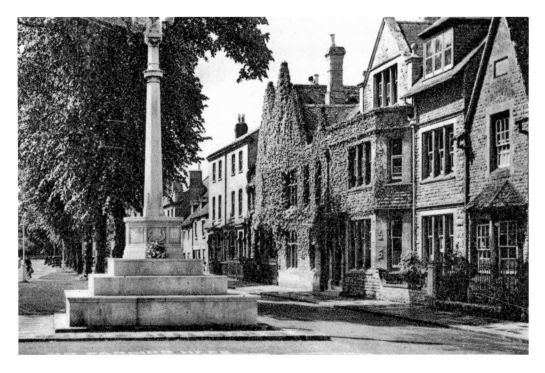

Church Green – The War Memorial

In addition to purchasing the Leys, the Witney War Memorial Committee erected a dignified memorial cross on Church Green, which was inscribed with 157 names and dedicated at a well-attended open-air service held on 19 September 1920. A further thirty-five names were added to the memorial after the Second World War. The Cotswold stone houses that line the western side of the green have changed very little, although the memorial has acquired its own small garden.

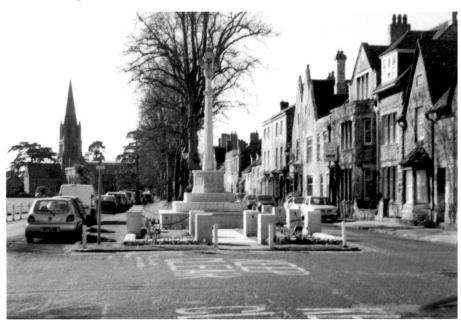

The Witney Railway – Entering the Old Station

The Witney Railway was opened from Yarnton Junction to Witney, a distance of 8 miles 13 chains, on Wednesday 13 November 1861. The original station was a small terminus near the parish church, which had a life of just over twelve years until, on 15 January 1873, it was replaced by a new station on the East Gloucestershire Railway's Fairford extension. This view was taken from a special train that ran to Witney on 24 May 1969. The station site has now been redeveloped as a supermarket and an industrial estate (below), although the former Witney Railway goods shed can still be seen amid the industrial units.

Inset: A ticket issued for the last train to Witney on 31 October 1970.

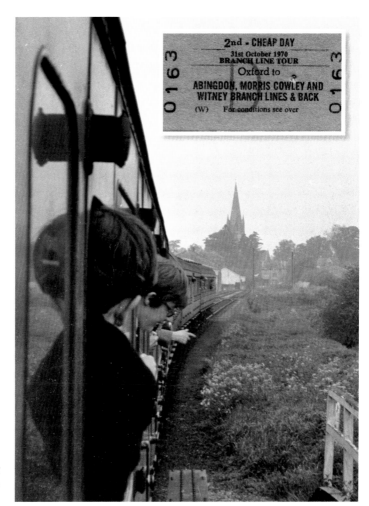

2nd - CHEAP DAY
31st October 1970
BRANCH LINE TOUR
Oxford to
ABINGDON, MORRIS COWLEY AND
WITNEY BRANCH LINES & BACK
(W) For conditions see over

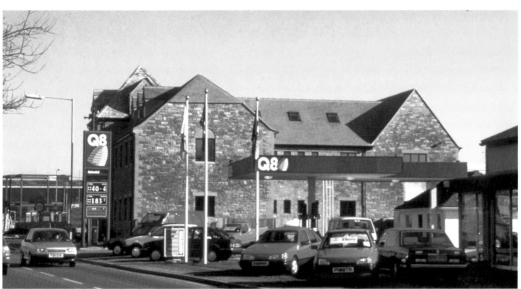

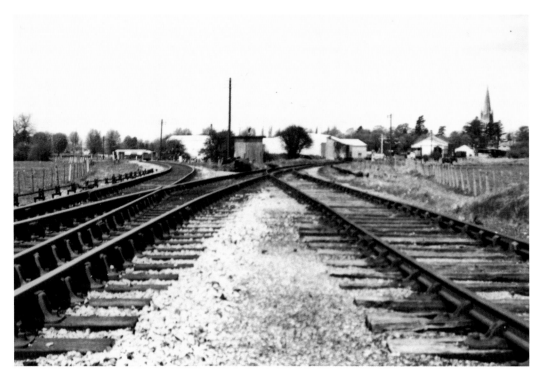

The Witney Railway – Witney Goods Junction

Witney Goods Junction in 1964, the right-hand spur being the 1861 Witney Railway, while the left-hand line was the 1873 extension to Fairford. The siding on the extreme right was used as a 'head-shunt' or shunting neck for the goods yard. The railway was closed to all traffic in 1970 and the site of the erstwhile junction is now a grass-covered open space.

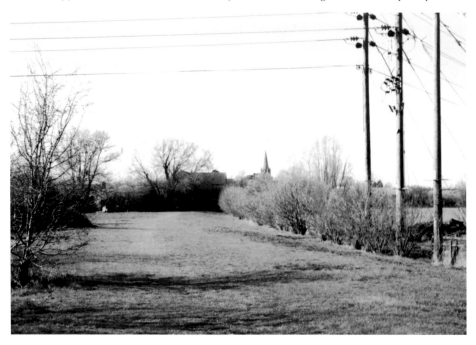

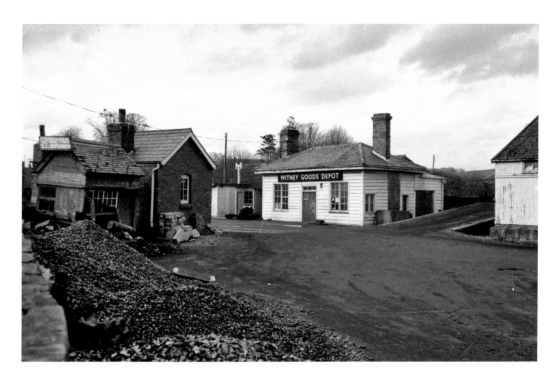

The Witney Railway – The 1861 Station

Witney's original station building became part of an enlarged goods station in 1873, when the line was extended to Fairford by a separate company known as 'The East Gloucestershire Railway'. The tumbledown wooden shack visible on the extreme left was Marriott's coal office, while the more substantial brick building beside it was the weigh-house. Witney station handled between 40,000 and 48,000 tons of freight per annum. Below: Sadly, this site has now been obliterated by a supermarket.

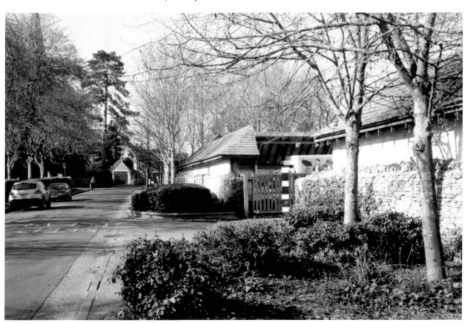

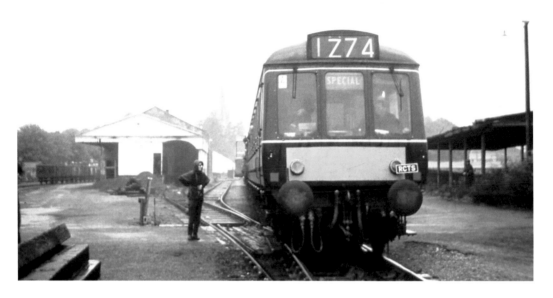

The Witney Railway – The Goods Yard

The 'Bicester & Thames Valley Railtour' stands outside Witney Old Station on 14 September 1968. The goods shed is visible in the background, while coal wagons occupy the sidings on the extreme left. Although the last scheduled passenger-carrying trains ran between Fairford and Oxford on Saturday 16 June 1962, special passenger trains worked through to Witney on a sporadic basis until the final closure in November 1970. The lower picture shows the still-extant goods shed in its present form.

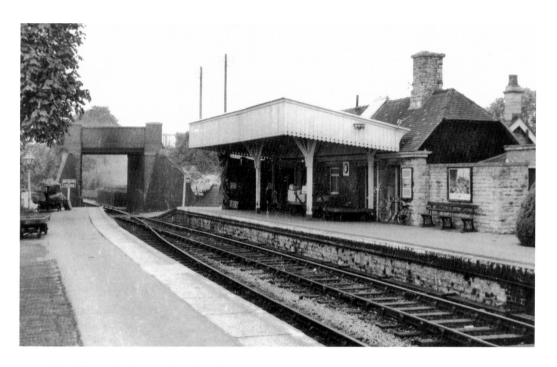

The Witney Railway – The 1873 Station

A general view of Witney 'New' Station, opened by East Gloucestershire Railway in 1873, showing the Cotswold stone station building on the up platform and the crossing loop which enabled up and down trains to pass each other on the single line. Much of the railway has now been replaced by industrial units, one of the new buildings being shown in the lower photograph. The parts of the line that have not yet been re-developed have reverted to nature.

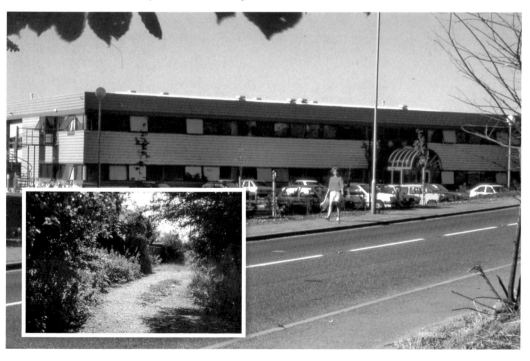

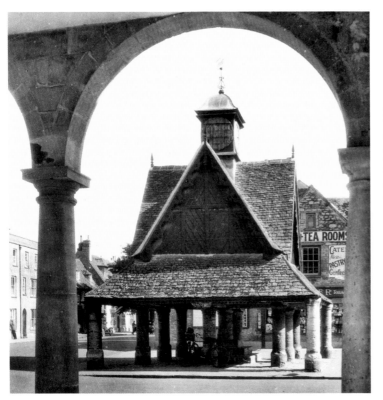

Market Square – The Buttercross

The famous Witney Buttercross was originally a religious shrine but, after the Protestant Reformation, it was adapted for use as a covered 'market house'. The gabled roof is thought to have been added in the early seventeenth century following a bequest from Richard Ashcombe, a gentleman of Curbridge, who in 1606 left £50 to the Bailiffs of Witney to be 'bestowed and layed-out in the building of an house over and above the Crosse of Witney'. However, the thirteen stout pillars that support the roof structure appear to be far older than the seventeenth century, and it is conceivable that the Buttercross may have had a medieval predecessor. The clock, with its cupola, was added in 1683 by William Blake of Cogges.

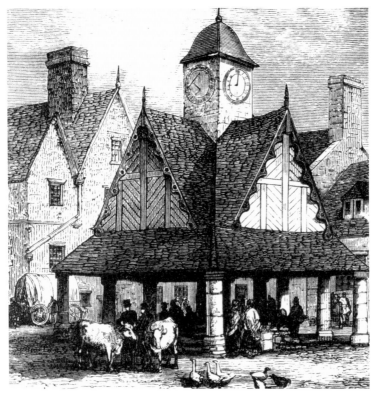

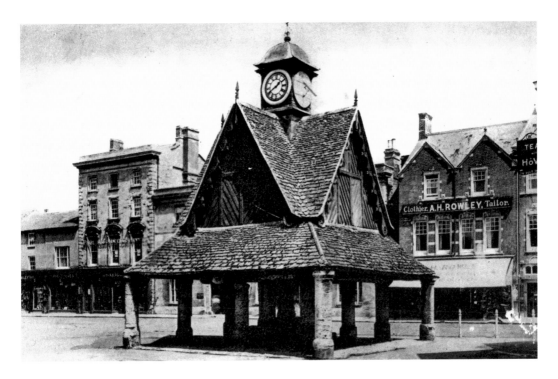

Market Square – The Buttercross

The Buttercross, facing north-east, in the 1920s. No. 29 Market Square, to the right of the picture, was A. H. Rowley's clothes shop, while no. 25, the tall building that features prominently to the left of the Buttercross, housed the Pearl Assurance Company. At that time, the Buttercross featured ornate timber gables, but these were subsequently replaced by plain, rendered gables, as shown in the later photograph; Rowley's has now become Keates' outfitters, while nos. 27 and 25 have been demolished.

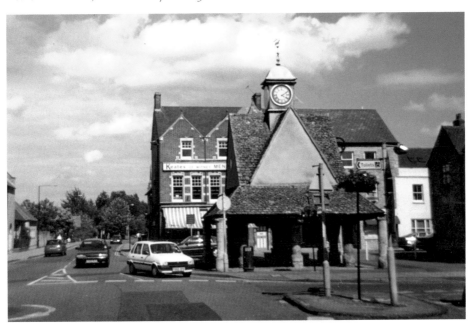

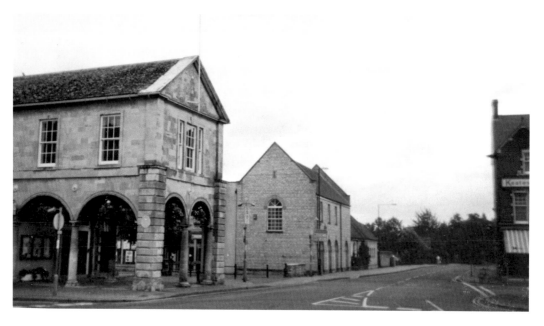

Market Square – The Crown Hotel

No. 27 Market Square, the former Crown Hotel, was important during the stage coach era. In its heyday, this three-storey building was rendered with plaster and colour washed, while the large gateway to the left of the doorway enabled vehicles to reach stables at the rear. The Crown ceased to be an inn in the 1850s, but it remained a prominent feature of Witney until the 1980s when, despite sustained protests, it was demolished to make way for the new 'Langdale Gate' road.

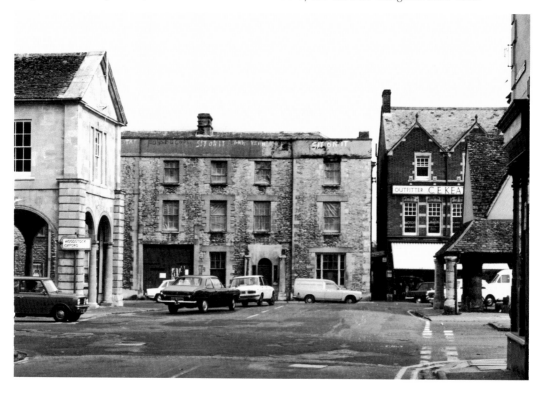

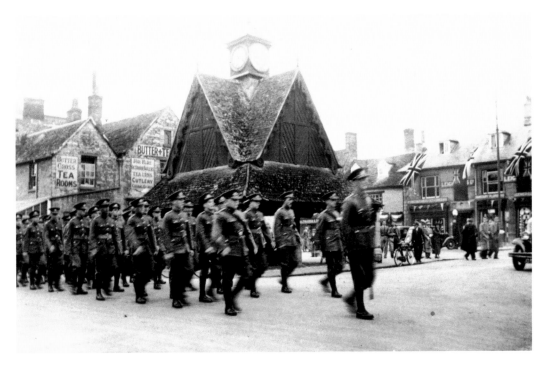

Market Square – The Oxfordshire & Buckinghamshire Light Infantry

It is believed the upper picture shows Territorials of the 4th Battalion, Oxfordshire & Buckinghamshire Light Infantry, marching past the Buttercross, possibly during the King George V Jubilee celebrations, which took place on 6 May 1935. The lower view, which shows the Buttercross from the same angle in 2012, underlines how new road schemes have changed the character of the square by turning it into a busy crossroads.

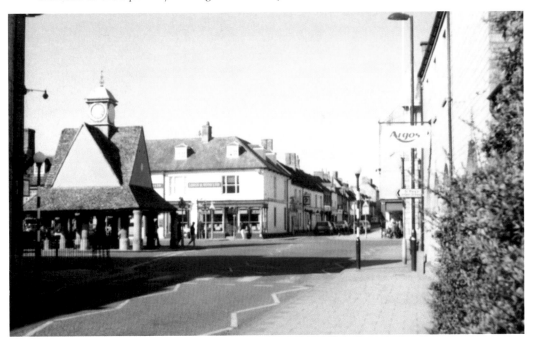

Market Square – Crown Lane

Until the untimely demise of the Crown Hotel, Crown Lane had provided a pedestrian link between Market Square, Langal Common and Cogges. The aperture between Keates' shop and the Crown was exceedingly narrow, but the path was nevertheless well-used by walkers and cyclists. The scene was utterly transformed by the construction of 'Langdale Gate' during the 1980s – the name chosen for this new road being somewhat confusing, as there has never been any kind of gate at this point. Most of the structures shown in the lower view are of recent construction, although care has been taken to ensure that they complement the older buildings in the town.

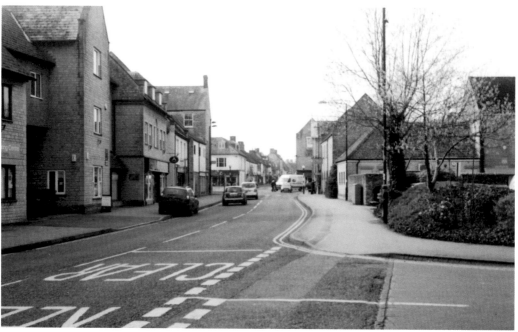

Market Square – Crown Lane & Langdale Gate

The upper picture shows Crown Lane, looking west towards Market Square during the 1970s. Although Langdale Gate has totally obliterated the western end of Crown Lane, the eastern and central portions of this narrow lane have remained *in situ* as a pedestrian pathway, as shown in the lower photograph, taken in 2012 – the alignment of the Cotswold stone walls being the same in both photographs.

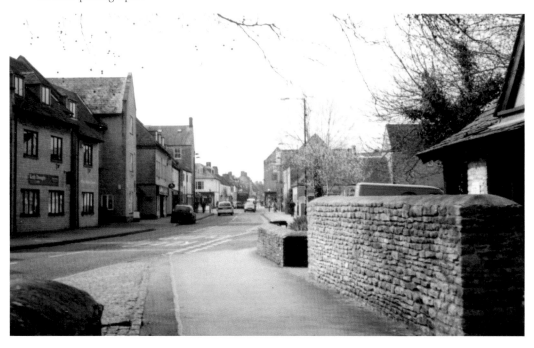

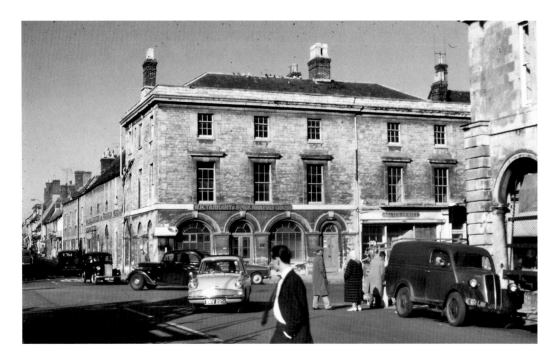

Market Square – Tarrant's Corner

Witney lost many interesting and attractive buildings during the 1960s and 1970s, when local politics were dominated by protracted, acrimonious and expensive planning disputes between the local authorities and bodies such as The Council for the Preservation of Rural England. The attitude displayed by the local council was exemplified by the destruction of W. H. Tarrant's former shop and warehouse on the corner of Corn Street and Market Square, which was replaced by a slab-sided structure of almost unbelievable ugliness (below).

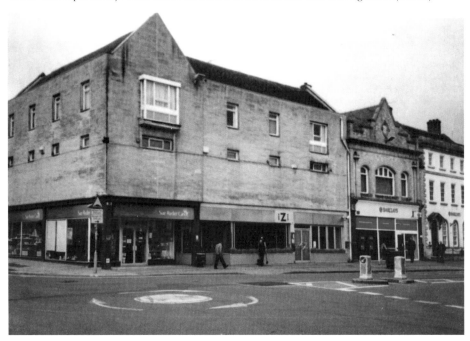

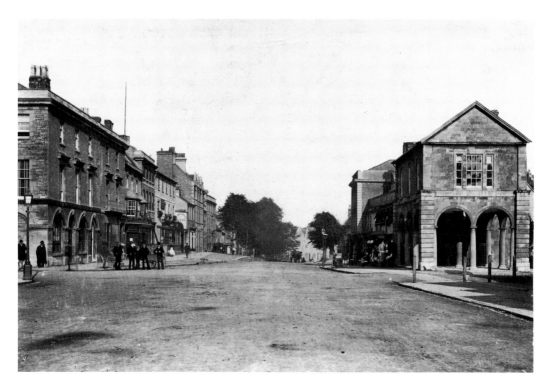

Market Square – Tarrant's Warehouse & the Town Hall

A general view of Market Square looking north, with Tarrant's wholesale warehouse to the left and the town hall to the right. The latter building, which replaced a much earlier town hall on the same site, dates from *c.* 1786 and was said to have been designed by Sir William Chambers (1722–96), who also designed Woodstock Town Hall. It incorporates a council chamber over an open loggia, the upper floor being supported on Tuscan columns.

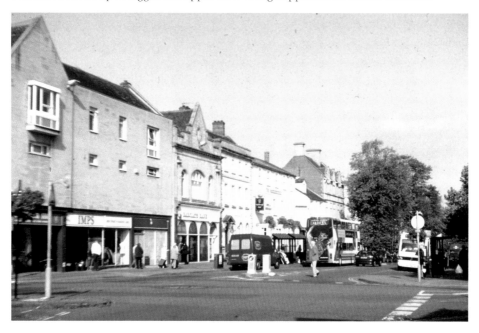

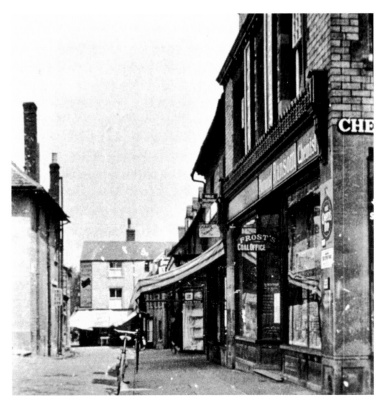

Market Square – The East Side

Two views showing the north-eastern corner of Market Square; the upper photograph dates from the 1920s. Although superficially, little seems to have changed, many of the buildings visible in the later view are modern – the local authorities wanted to demolish various listed buildings in order to implement their cherished road-construction schemes. At one stage, the Corn Exchange, visible in the lower photograph, was threatened with destruction, but in the event this mid-Victorian building, dating from 1863, was spared. Ransom's chemist shop at no. 17 Market Square, which can be seen to the right of the upper picture, was demolished instead.

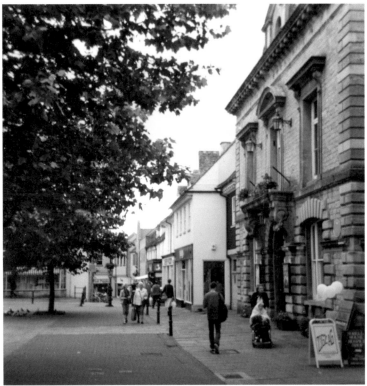

Market Square – The Palace Cinema

Witney's first cinemas were opened during the early twentieth century, one of these being housed in a wooden building at the lower end of Corn Street, while the 'The Electric Theatre' was opened at 31 Market Square around 1913. The 1916 edition of *Knight's Directory of Witney* reveals that the name had, by that time, been changed to 'The People's Palace' while, as a result of a subsequent renaming, it later became 'The Palace Cinema'.

The cinema was rebuilt in a restrained art deco style during the early 1930s, the main façade being set back from the pavement to make room for an open-fronted forecourt or loggia. A small cafe on the right hand side of the loggia was known as 'The Palace Parlour'. Internally, the auditorium consisted of a large hall with a balcony and a gently-sloping floor, the 'tip-up' seats being divided into two blocks by an off-centre aisle. The gallery boasted its own carpeted foyer, which gave an added feeling of luxury for those who could afford the best seats in the house!

Faced with declining audiences, the cinema closed in the mid-1980s and the 'Palace Cinema' was used as a health club and gymnasium, before becoming a nightclub. The building was re-opened as a J. D. Wetherspoon pub on 21 February 2012 , its present name being 'The Company of Weavers'.

Inset: The Palace in use as a nightclub, with a modified façade.

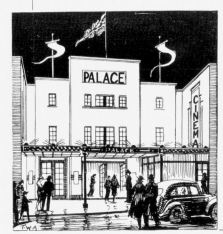

● *Make a habit of meeting your friends at the—*

PALACE CINEMA

where up-to-date entertainment, in attractive and comfortable surroundings, is always available

Renowned Far and Wide for its Perfect Sound Reproduction.

Prices
6d. to **1/10**

Showing, Evenings,
Saturdays 5.15 & 8
Other days
 5.45 till 10.30
Matinees Thursdays
& Saturdays at 2.0

Tel. Witney 147

MARKET SQUARE WITNEY

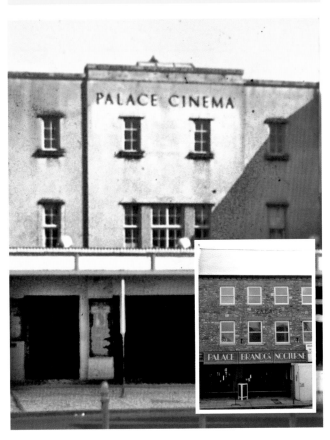

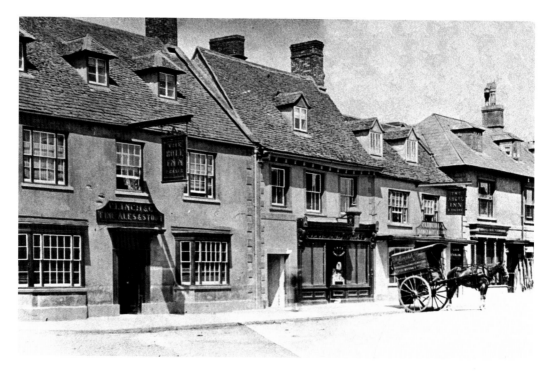

Market Square – The Angel & The Bull

This detailed view shows some of the old houses on the west side of the square, including The Bull, at no. 46, and its near-neighbour The Angel, at no. 42. The intervening property, no. 44, was Messrs Saltmarsh & Druce – a well-established grocery business. The Bull is now used as offices and a bookshop, while Druce's has become a Thai restaurant, although the Angel is still functioning as a popular town centre pub, offering food and a choice of real ales.

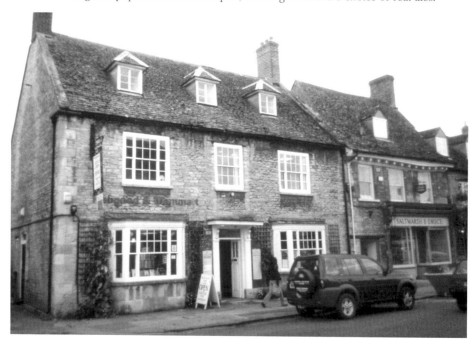

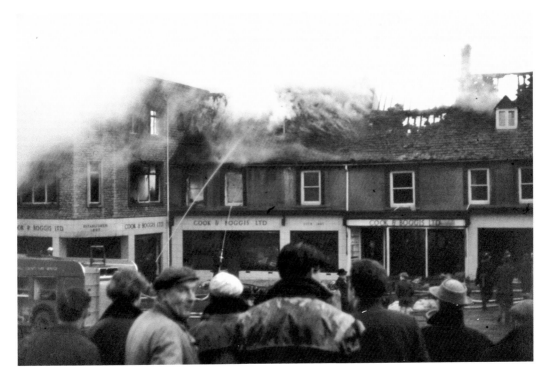

Market Square – The Cook & Boggis Fire

On 17 December 1964, fire broke out at nos. 3, 5 & 6 Market Square – a large store belonging to Messrs Cook & Boggis Ltd. Flames were soon bursting through the roof and threatening adjacent premises, while a vast crowd blocked the pavements and hampered the firemen. Eventually, after an operation lasting over twenty-four hours, the fire was extinguished and an ugly gap was then left on the eastern side of the street. The replacement buildings were of controversial modern appearance.

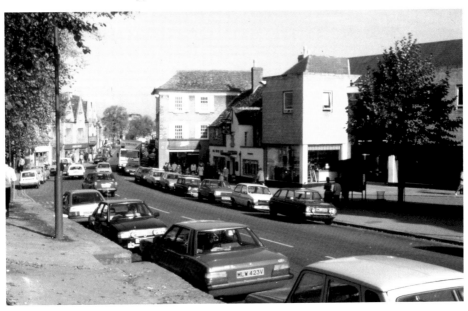

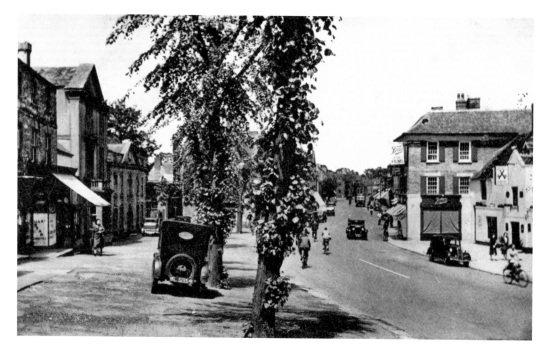

Market Square – The Hill

The buildings on the north-western side of Market Square are higher than their counterparts on the eastern side, insofar as they are sited on a raised terrace known as 'The Hill'. The sepia photograph, looking northwards towards the High Street, was taken in the 1920s, while the colour view was photographed from a similar vantage point around eighty years later. No. 2 High Street, formerly the Temperance Hotel and now Boots the Chemist, can be seen to the right in both views.

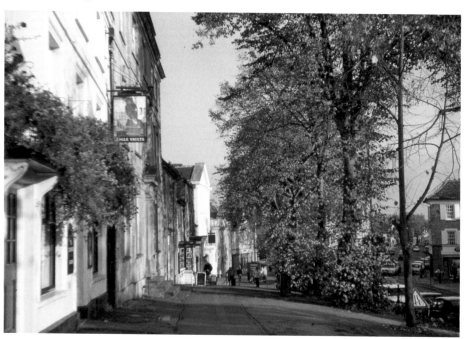

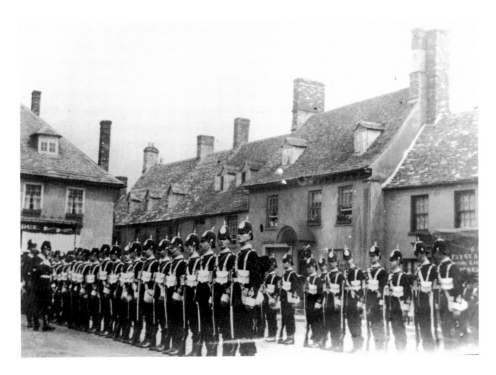

Market Square – The 2nd Volunteer Battalion

Members of the 2nd Volunteer Battalion, Oxfordshire Light Infantry, drawn up in the Market Square, *c.* 1890. It is assumed that the volunteers are about to march to the railway station, from where a special train will convey them to their annual summer camp. The hip-roofed building to the left of the picture, no. 49 Market Square, subsequently became Messrs Neave & Leas' chemist shop, and is now an Oxfam charity shop (below).

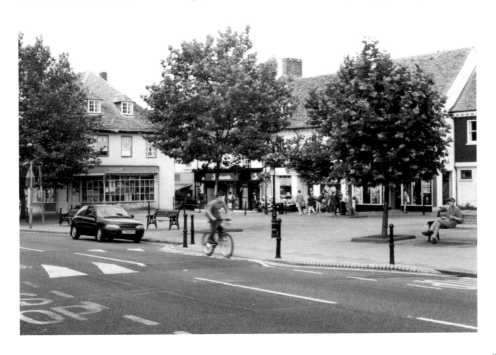

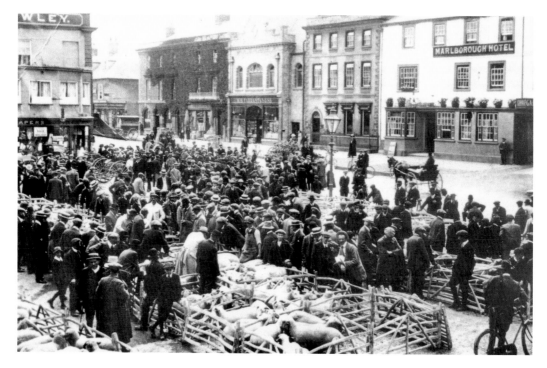

Market Square

The earlier photograph shows a cattle market in progress in Market Square, probably *c.* 1912, while the recent view shows a similar scene around 100 years later. The Marlborough Hotel, no. 28 Market Square, can be seen in both pictures, together with no. 30, formerly Gilletts Bank and now Barclays. Tarrant's wholesale warehouse is no more, but no. 32, W. H. Tarrant & Sons' former grocery store, with its ornamental gable, has now been incorporated into Barclays Bank.

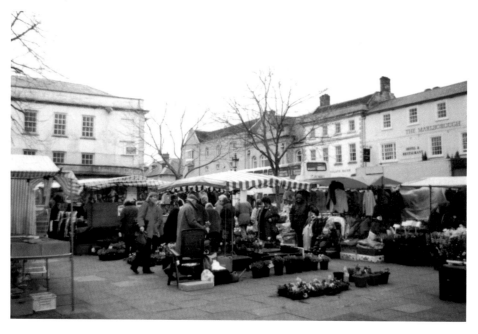

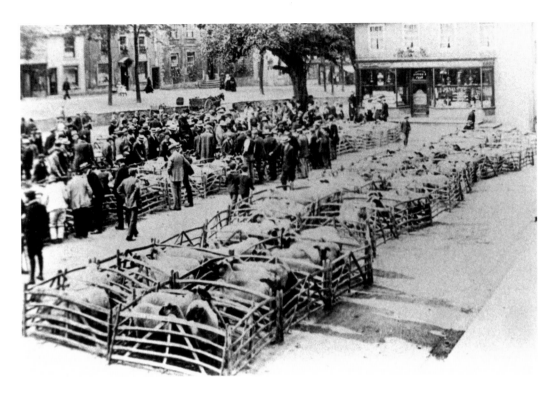

Market Square

A pair of similar views, both of which are looking north towards the High Street. Witney cattle market was later moved to a new site at the rear of the Corn Exchange, on the east side of the square.

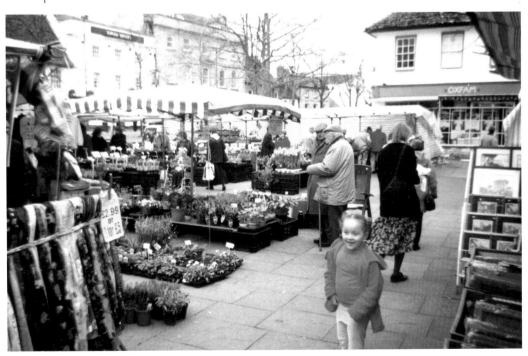

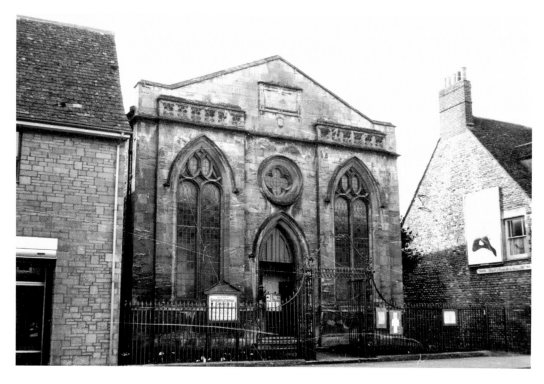

High Street – The Congregational Chapel

Independents (or Congregationalists) have worshipped in Witney since 1662. The Congregational chapel in High Street was opened on 1 October 1828, replacing an earlier chapel in Meeting House Lane, which is now the scout hall. The Manse at the rear of the chapel was purchased, along with an orchard and gardens, in 1827, with the cost of the transaction being £700! Sadly, in 1969, the entire property – both church and Manse – was sold to make room for a supermarket.

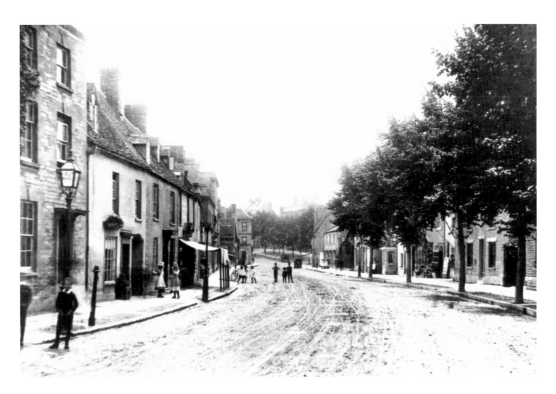

High Street – Looking South

A general view of the High Street looking south towards Market Square, *c.* 1900, and a recent view taken from a similar viewpoint. Although these two scenes are superficially similar, there have been considerable changes on the west side of the street. At one stage, every building between nos. 7 and 29 was threatened with demolition in connection with re-development and the construction of Welch Way (named after a town clerk), which leaves High Street at the mini-roundabout visible in the centre of the recent picture.

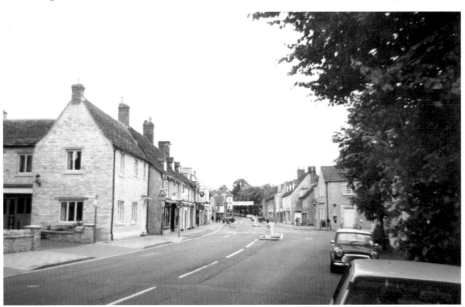

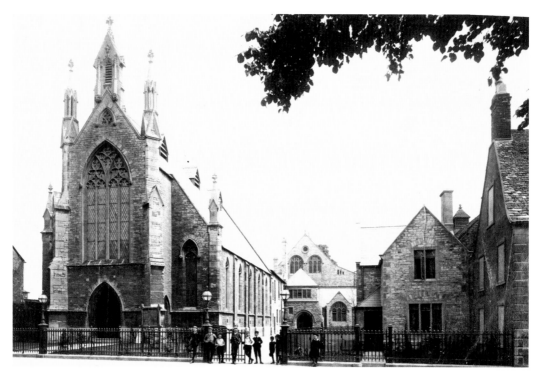

High Street – The Wesleyan Chapel & School

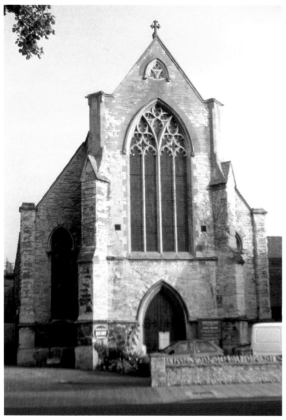

Methodism became particularly strong in Victorian Witney and on 22 February 1850, a new chapel was opened by the Reverend Jabez Bunting, who had inherited John Wesley's role as head of the Methodist Church. This new place of worship, which was designed by James Wilson of Bath, was sited to the west of an earlier chapel in the High Street; it featured a steeply-pitched gable roof, with towering pinnacles and tall Gothic windows.

A Wesleyan school was opened at the rear of the chapel in 1851 – the Methodists having rejected the idea of sharing the Anglican Schools. By 1853, the Wesleyan School had over 130 pupils, together with one master and two pupil-teachers. The school was enlarged in the 1880s, by which time it had started to provide a commercially oriented syllabus, with an emphasis on scientific and vocational subjects.

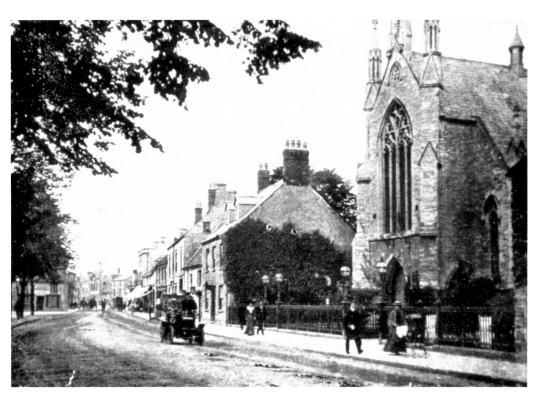

High Street – Looking North

Looking northwards along the High Street from the Wesleyan Chapel around 1912 (above), and eighty years later (below). Apart from the shop fronts, little has changed, although the ornamental iron railings in front of the chapel were carted away for scrap during the Second World War.

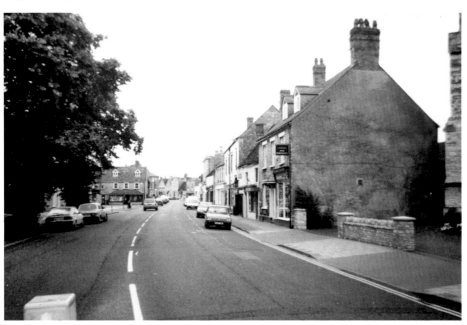

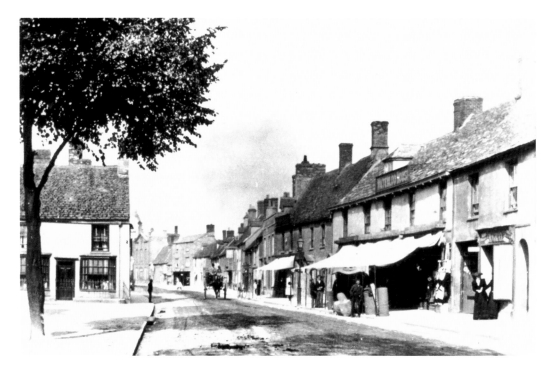

High Street – Waterloo House

The building visible towards the right of this *c.* 1890 photograph, no. 58 & 60 High Street, was known as 'Waterloo House'. It was occupied by G. Osborn Tite and was, for many years, a well-known Witney draper's shop, catering for both ladies and gentlemen. The building is now known as 'Waterloo Walk' and, as such, it forms part of a complex of small shops. No. 56 High Street, on the extreme right, was H. Grey's bakery, but it subsequently became Quelch's greengrocer's shop.

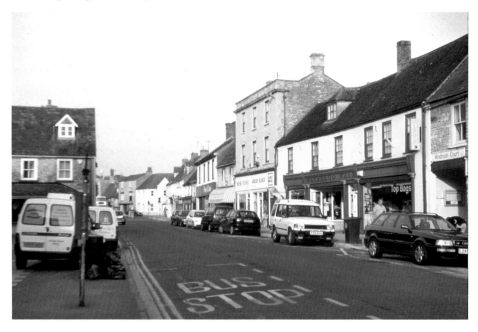

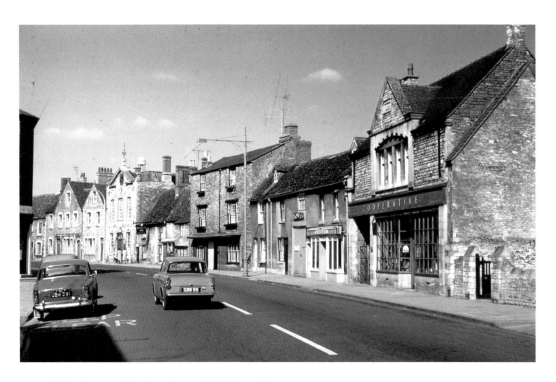

High Street – The Junction with Witan Way

The construction of the new roads known as 'Witan Way' and 'Langdale Gate' necessitated the destruction of several buildings, including the historic Crown Hotel and the Co-operative food store and neighbouring properties at the upper end of High Street. The lower picture shows the present junction between High Street and Witan Way, together with new buildings which have appeared at the north corner of the road junction.

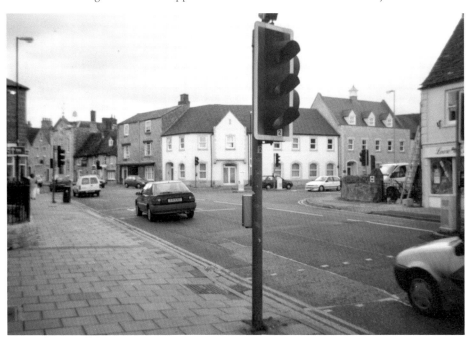

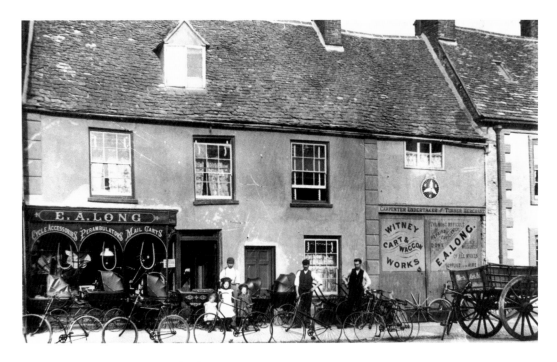

High Street – Long's Cycle Shop

E. A. Long's premises were sited at 108–110 High Street, near the junction with Bridge Street and Mill Lane. The 1916 edition of *Knight's Directory of Witney* shows that no. 10 was a 'cycle & motor' shop, while 108 High Street was a 'wheelwrights' – although study of the photograph suggests that it was also a 'cart & wagon works' and an undertaker's! The property has, in more recent years, become Mike Wheeler's motorcycle shop.

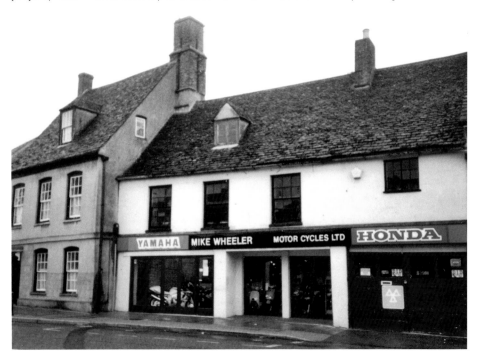

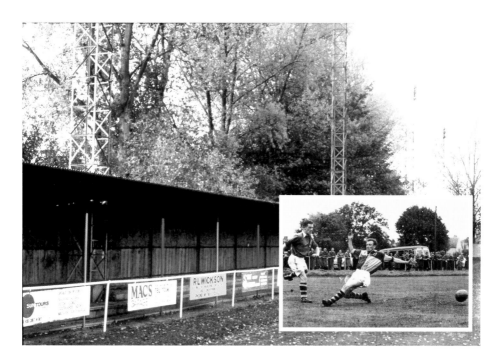

Marriott's Close

An open space known as Marriott's Close, which was situated immediately to the west of the High Street, was given to Witney Town Football Club by the Marriott family, who envisaged that the field would provide recreational facilities for the townsfolk in perpetuity. However, Marriott's Close was later acquired for re-development by West Oxfordshire District Council. The upper picture shows covered stands on the west side of the pitch, while the lower picture shows the new development known as Marriott's Walk.

Inset: A football game in progress at Marriott's Close, *c.* 1950s.

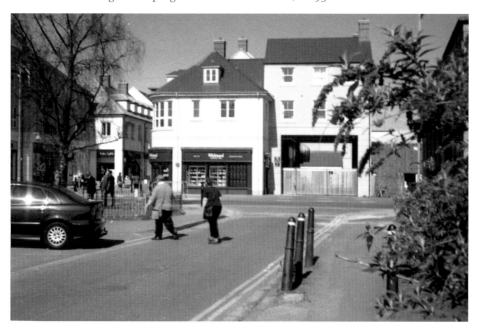

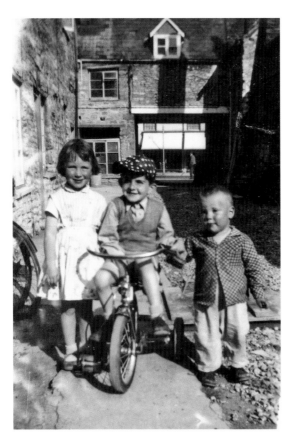

Cresswell's Yard

Cresswell's Yard, on the west side of High Street, contained a row of four cottages and a larger detached house. The cottages visible to the left were numbered 55D, 55C, 55B and 55A. The children seen in this 1950s picture are: (left to right) Dolores Lorraine Mazarasso, Stanley Jenkins and Roy Mazarasso. Yards and alley-ways such as Cresswell's Yard were known in Witney as 'tewries'.

In 1927, no. 55A was the scene of an unexplained fire tragedy in which Mrs Harris was burned to death in her own bed, having apparently made no attempt to escape from the flames. Her young daughter, who was present at the time, was unable to provide any reliable information, although a candle was found near the bed.

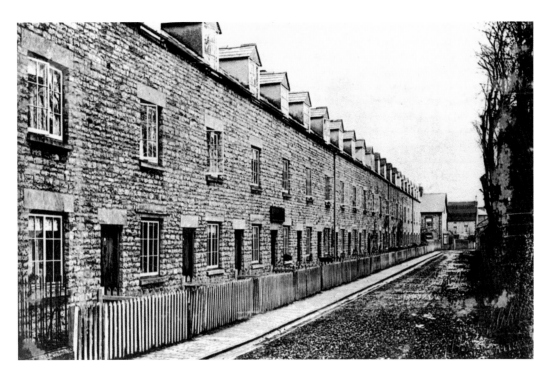

Gloucester Place

Industrial terraced housing was unknown in Witney – the mill workers lived in traditional Cotswold stone cottages in and around the town. There are, however, one or two stone terraces, notably these substantially built houses, known as 'Cape Terrace', on the north side of Gloucester Place. The upper view, taken *c.* 1900, is looking east towards the High Street, whereas the recent view is looking in the opposite direction towards Cape Terrace.

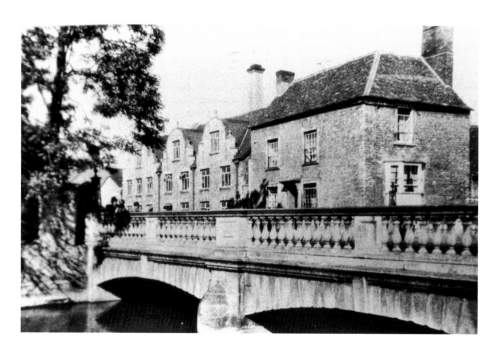

Bridge Street Mill & Bridge

Bridge Street Mill was opened in 1866 by William Smith (1815–75). In 1840, the site of the mill had consisted of several diverse properties including houses, gardens, stables, outbuildings and a national school. As first constructed, the mill was partially-hidden behind these older buildings, but the construction of the new façade, with its triple Jacobean-style gables, transformed the appearance of the mill in a most attractive way. The mill was closed in 1975.

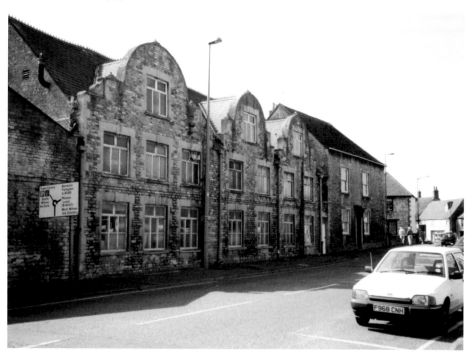

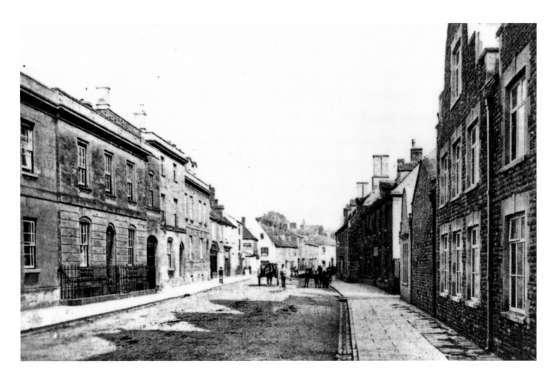

Bridge Street Looking North

This *c.* 1912 view is looking northwards along Bridge Street, with Bridge Street mill on the extreme right of the picture and a group of attractive, Georgian-style buildings to the left. The lower view, taken from the bridge a century later, reveals that the scene has hardly changed. The bridge, which is shown in more detail on the previous page, was rebuilt with two spans in 1926 – until that time it had been a three-span structure with a pronounced 'hump'.

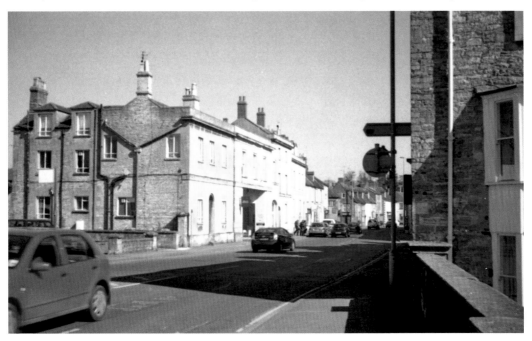

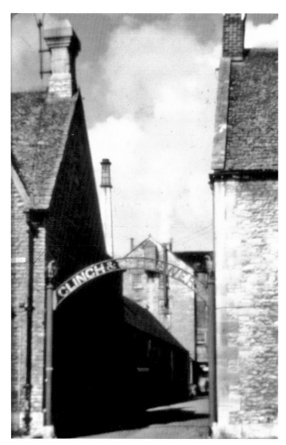

The Crofts – Clinch's Eagle Brewery

In 1811 the Clinches, a prominent local banking family, purchased the Marlborough Head on Church Green, and established a small brewery at the rear of the inn. John Williams Clinch (1787–1871) assumed control of the firm around 1828, and in the 1830s John Williams and his brother James Clinch (1788–1867) established Clinch's 'Eagle Brewery' on an extensive site between Church Green and 'The Crofts'. Completed around 1840, the brewery incorporated an impressive four-storey brewing tower of red brick and Cotswold stone, with a tall stone chimney stack. In addition the site included outhouses, stores, granaries, cart sheds and a large malthouse.

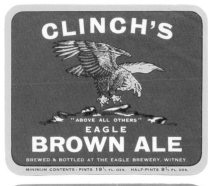
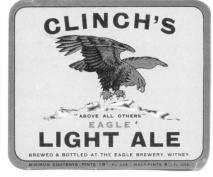
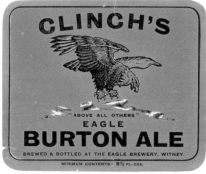
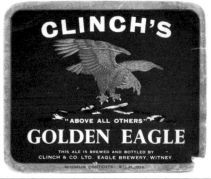

The Crofts – Clinch's Eagle Brewery

Clinch's Brewery was taken over by Courage in 1963 and brewing in Witney ceased, although the Eagle Brewery was used as a Courage distribution depot for several years, before finally closing in 1978. The main brewery building was demolished to make room for the Eagle Industrial Estate, although a micro brewery was subsequently set up in one of the industrial units, and after many vicissitudes this new venture became the Wychwood Brewery, which is now well-established in Clinch's former malt house at the 'Crofts' end of the site.

Above: These *c.* 1950s Clinch bottle labels, which were salvaged from the Eagle Brewery after brewing had ceased, recall some of the now-defunct local brews. Clinch's ale was said to have had a bitter 'fruity' taste – similar, perhaps, to unsweetened grapefruit juice.

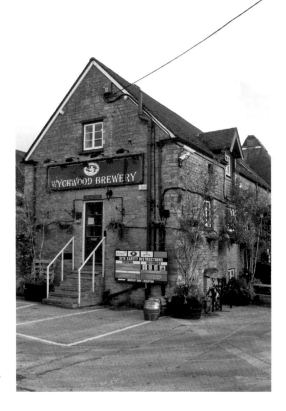

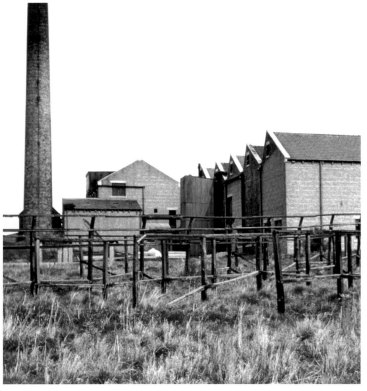

Crofts Mill

Crofts Mill was built in 1931–33 by James Walker & Co. of Mirfield at a cost of £19,000. Similar in style to the firm's Yorkshire factories, Crofts Mill was basically a large red brick weaving shed with a 'northlight' pattern roof, and when opened it housed forty-eight power looms. The main block was approximately 300 feet long, while peripheral buildings included the usual offices and store sheds, together with a boiler house and a cylindrical brick chimney stack. In all, the mill incorporated 5,250 square yards of floor space. The mill was closed in May 1980 after a working life of just forty-seven years, and the redundant factory was then demolished, the site being cleared to make way for speculative housing developments.

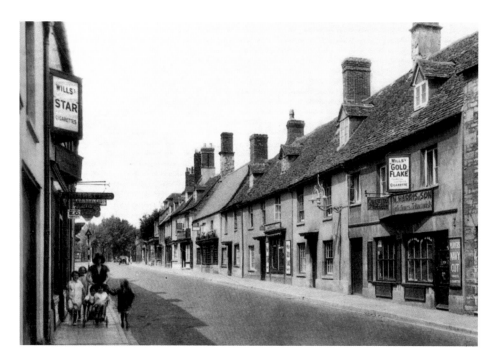

Corn Street – The Eagle Tavern

Corn Street, looking west, *c.* 1930s (above) and some sixty-five years later. In architectural terms, this street has changed very little, although individual traders have come and gone. The building with the blue-green rendering is no. 22, The Eagle Tavern, which was the last Witney pub to retain its traditional layout of two small bars and a connecting passage with benches for children to sit on. Gordon Rollins, who ran the Eagle from the 1950s until 1999, was Witney's longest-serving landlord.

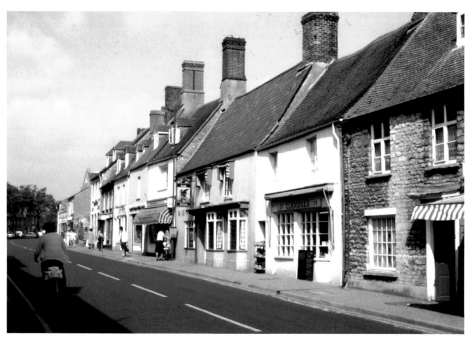

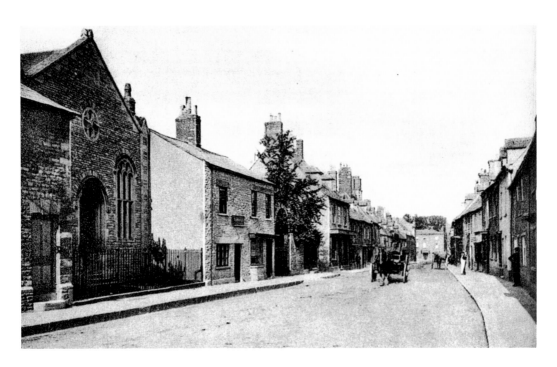

Corn Street – The Primitive Methodist Chapel

Corn Street, looking east towards the Butter Cross, with the Primitive Methodist Chapel visible to the left. The Primitive Methodists were founded by Hugh Bourne, a Staffordshire millwright, during the early nineteenth century. A Primitive Methodist chapel was in existence in Witney by 1845, and this became a Sunday school following the erection of a new chapel in 1869. The chapel became a launderette in the 1960s, but it is now used as a 'deli' bar and barber's shop.

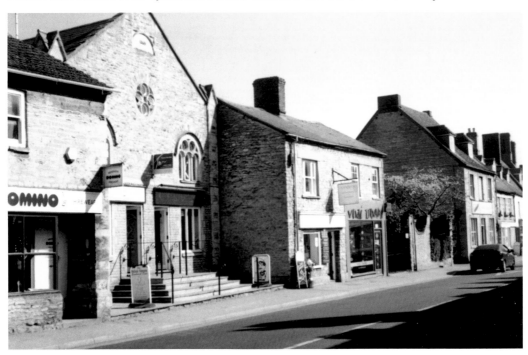

Corn Street Fire – Collier's Former Blanket Factory

Horatio Colliers' Blanket Factory was a three-storey structure adjoining no. 34 Corn Street. Although the building had no power source, it was one of the largest blanket-making establishments in the town during the early Victorian period. The *c.* 1840 tithe map reveals that Collier's property comprised a house, close, weaving shop, bleaching-house, yard and gardens – the reference to bleaching being surprising in view of the lack of a water supply.

Colliers ceased operations around 1879 and the former blanket factory became an agricultural works, though in the 1920s it was used as a glove factory. In 1929, the property became the Swan Laundry and, as such, the building was burned down in March 1937, as shown above.

However, the former blanket factory was soon rebuilt with a mansard roof and a tubular steel chimney. The building burned down for a second time on 22 October 1993, after which new houses were built on the site.

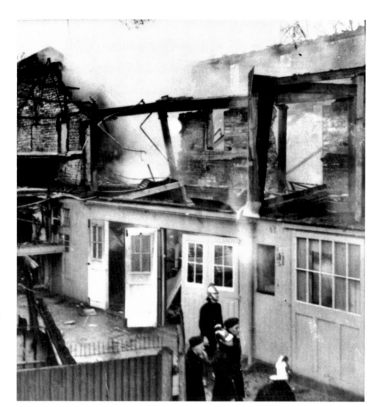

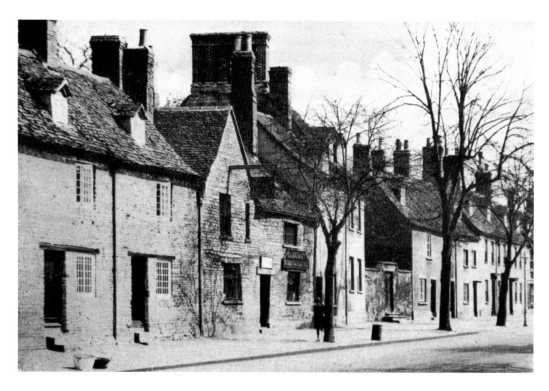

Corn Street – The Three Horse Shoes

Corn Street, looking east *c.* 1920s, showing no. 74, The Three Horse Shoes, and other picturesque old buildings on the north side of the street. The cottages visible to the left of the earlier photograph were pulled down in the 1950s to make way for Holloway Road, although a residual section of the demolished buildings remains embedded in the end wall of the pub.

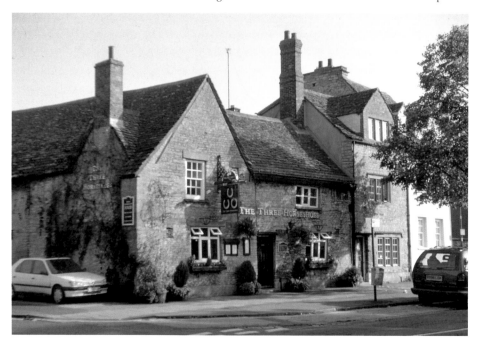

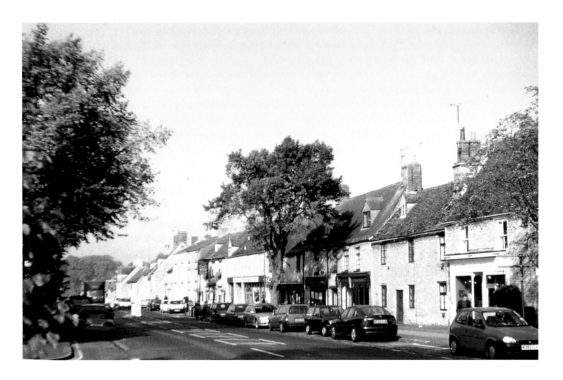

Corn Street – Looking West

Two views of Corn Street, looking west towards Tower Hill in the early 1900s (below), and over a century later (above). No. 104, The Butcher's Arms, which can be glimpsed to the right of the horse-drawn vehicle in the lower view, is still extant, but no. 100, The Nag's Head, just two doors along the street, is no longer a pub.

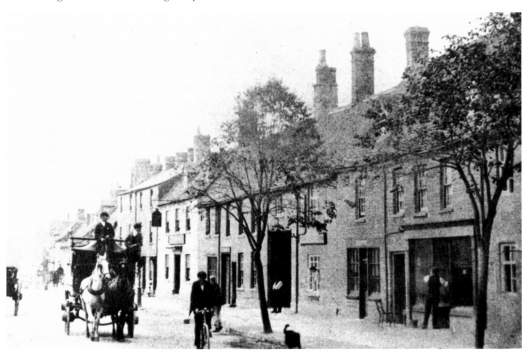

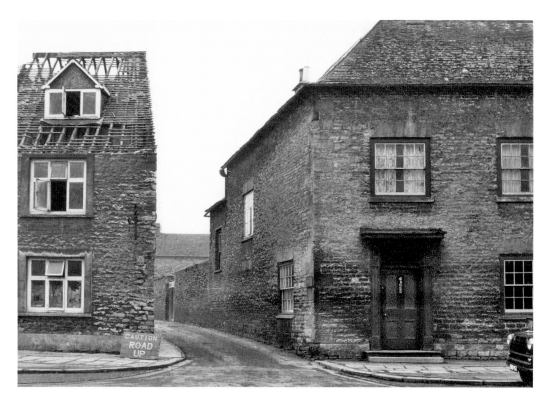

Corn Street – The Entrance to the Crofts

The area of land to the south of Corn Street was known as 'The Crofts' or 'West Crofts' as early as the Tudor and Stuart periods, though in recent years the name has been used to denote two narrow lanes that run due south from Corn Street towards the Leys. The entrance to the Crofts was widened during the 1960s, necessitating the demolition of property on the west side of Corn Street, as shown in the lower photograph.

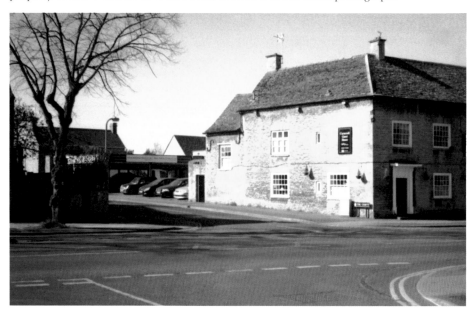

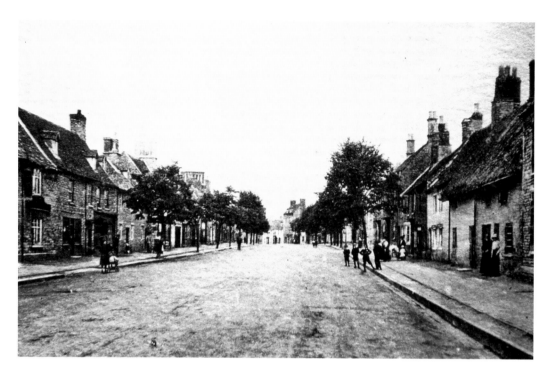

Corn Street – Buildings on the North Side

A general view of Corn Street, looking east towards Market Square, during the early years of the twentieth century. The demolition of houses on the south side of the street to provide improved access to the Crofts enables the buildings that are hidden by trees in the left centre of the upper picture to be photographed at right angles, as shown in the lower picture. Most of these properties are of eighteenth-century origin.

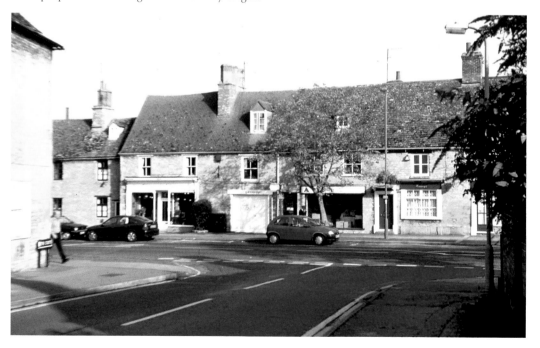

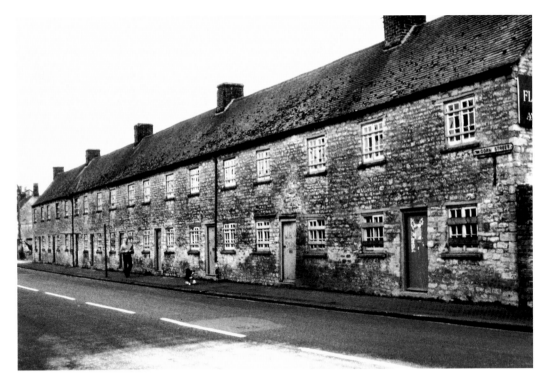

Corn Street – Buswell's Row

These nine cottages, known as 'Buswell's Row', nos. 159–175 Corn Street, were demolished in the early 1970s to make way for new housing developments – despite opposition from the Council for the Preservation of Rural England. The CPRE was, at that time, deeply concerned about the unnecessary destruction of historic buildings in Witney and the flagrant 'contraventions of planning consent and damaging alterations to listed buildings', which the council allowed to continue. The replacement buildings are shown below.

Inset: Demolition commences.

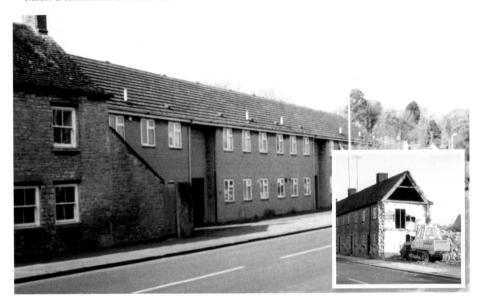

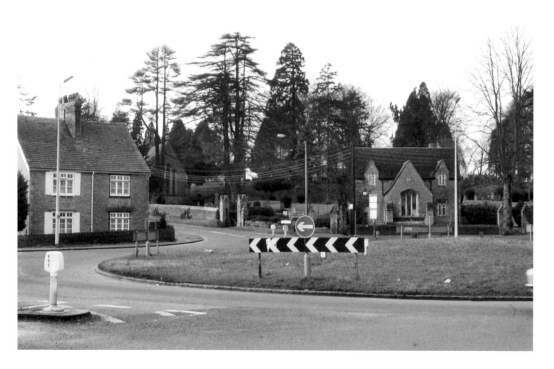

Tower Hill – The Junction with Welch Way

The present roundabout at the western end of Corn Street marks the point at which Corn Street converged with Ducklington Lane, Curbridge Road, Tower Hill and Dark Lane. When opened in 1857, the cemetery, visible beyond the roundabout, contained a consecrated section for Anglicans and an unconsecrated section for non-conformists, together with separate Anglican and non-conformist mortuary chapels and a keeper's lodge – these three Gothic-style buildings having been designed by William Wilkinson.

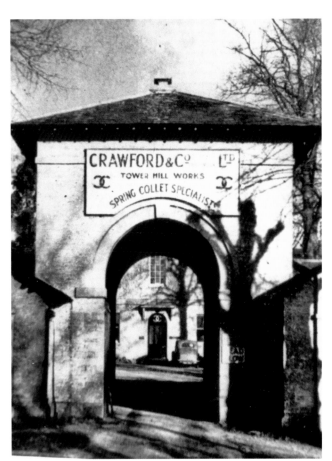

Tower Hill – The Union Workhouse

Witney workhouse was erected in 1835 to a design by George Wilkinson (1813–90) of Witney. It was one of the first 'new workhouses' to be built under the provisions of the 1834 Poor Law Act; the paupers themselves being pressed into service as quarry labourers. The completed workhouse consisted of a central tower with radial wings, containing accommodation for 450 paupers. There was also a gatehouse and porter's lodge, together with stables and an administrative block, while a chapel was added in 1860. In 1941, Crawford Colletts Ltd relocated from London to Witney, and transformed the old workhouse into an engineering factory. Most of the workhouse was demolished in 1976, although the administrative block (below) and chapel, have survived.

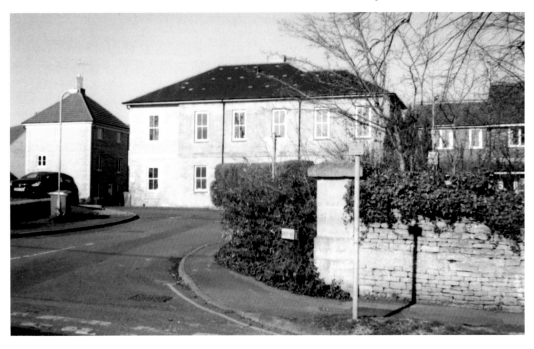

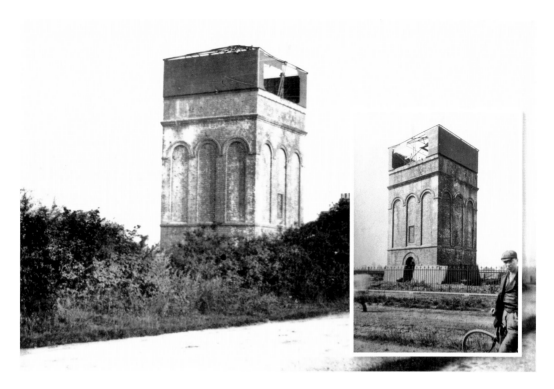

Tower Hill – The Water Tower

In 1903, Witney Urban District Council completed a water-supply system, with a pumping station at Apley Barn and a water tower containing 80,000 gallons of water on Tower Hill (then known as Union Hill). It's construction required over 90,000 bricks and the cost was £6,000. Sadly, the tank burst shortly after its opening and flooded the surrounding area. The tower was demolished *c.* 1938, but the 'Engineer's House' remains on the corner of Tower Hill and Burford Road (bottom inset).

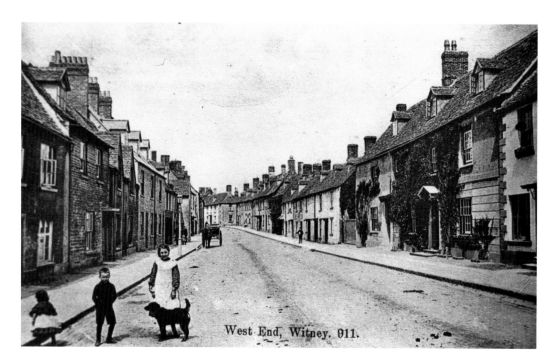

West End, Witney. 911.

West End – Looking West

The street known as West End, which runs due west from Bridge Street, was one of the most populous parts of Victorian Witney and, in addition to residential accommodation, it was also the site of various blanket factories and weaving shops, including a relatively large complex of mainly eighteenth-century buildings at the rear of no. 55 West End, which was used as a blanket and mop-making factory by Edward Early & Co.

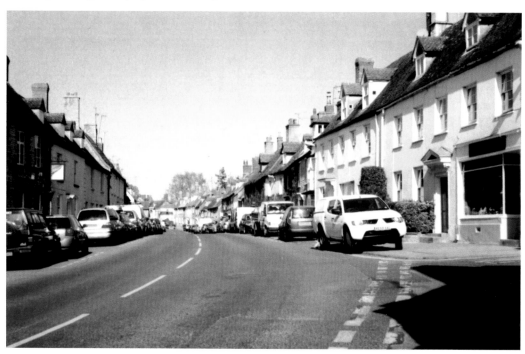

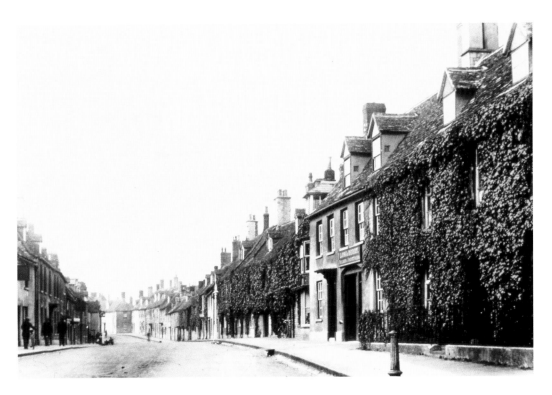

West End – The 'Old-Fashioned Street'

Another view of West End, looking west, *c.* 1912. It is interesting to recall that West End was associated with the First World War song 'The Old-fashioned Town', first sung in 1914. The writer of the song, Miss Ada Leonora Harris, used to stay in an 'Old-fashioned House' at 48 West End with her Aunt and Uncle – the 'Old-fashioned Pair' of the song. In its heyday, the 'Old-fashioned Town' was almost as popular as 'Pack Up Your Troubles' and 'Tipperary'.

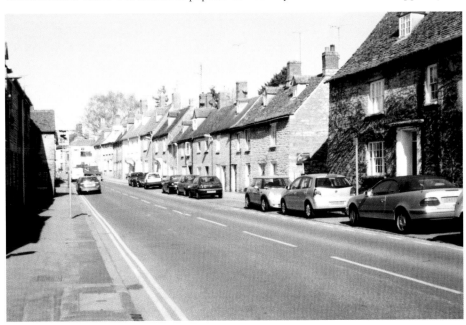

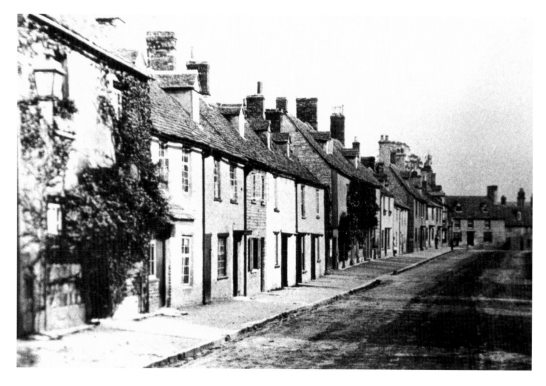

West End – Looking East

An Edwardian view of West End, looking east towards Bridge Street, and showing some of the Cotswold stone houses on the north side. No. 48, 'The Old-fashioned House', is second from the left in the lower photograph. When the song was written in 1914, the house was entirely covered in Virginia creeper, with purple clematis around the porch and red geraniums in the window boxes.

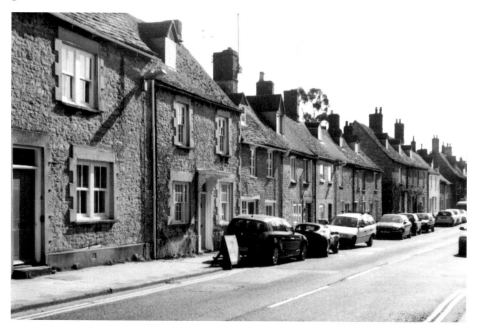

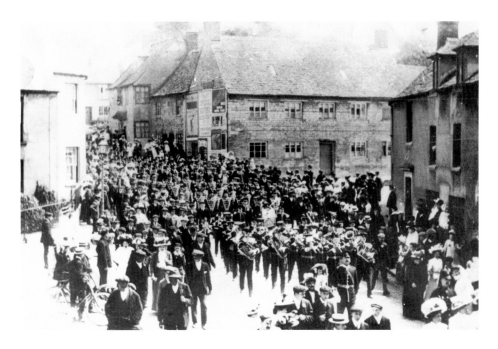

West End – Staple Hall Corner

The sepia photograph shows a procession descending Broad Hill, with Newland to the right and West End to the left of the picture; the soldiers, who are wearing busbies, appear to be members of The Queen's Own Oxfordshire Hussars. The buildings on the extreme right were subsequently demolished to create a more spacious road layout as shown in the recent photograph. The gabled building seen on the right of the colour photograph is Staple Hall, a former coaching inn.

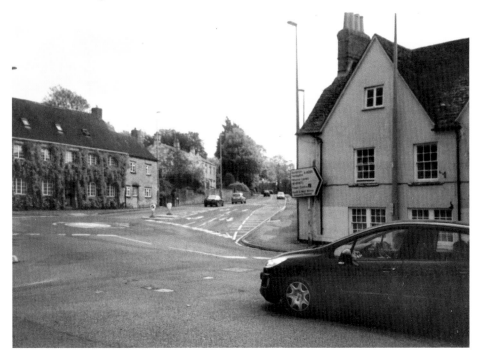

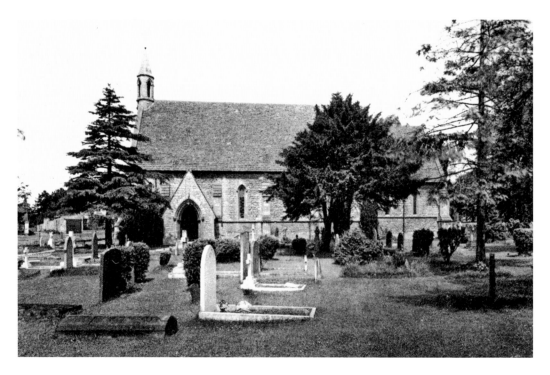

Wood Green – Holy Trinity Church

Holy Trinity Church is an Anglican chapel-of-ease that was constructed on Woodgreen, ostensibly for the benefit of people living at the north end of the town who would 'not have to walk the distance to the Parish Church'. It was designed by Benjamin Ferrey and built in just one year, the foundation stone being laid on 5 May 1848, while the new church was consecrated on Wednesday 11 July 1849 by Samuel Wilberforce, the Bishop of Oxford.

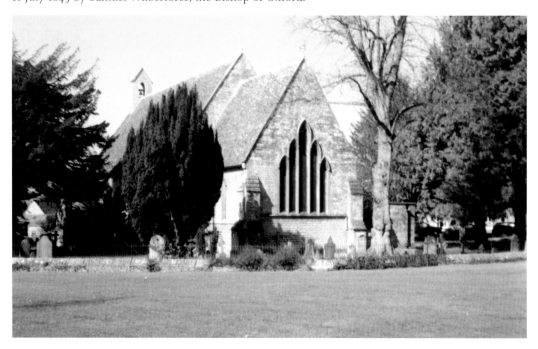

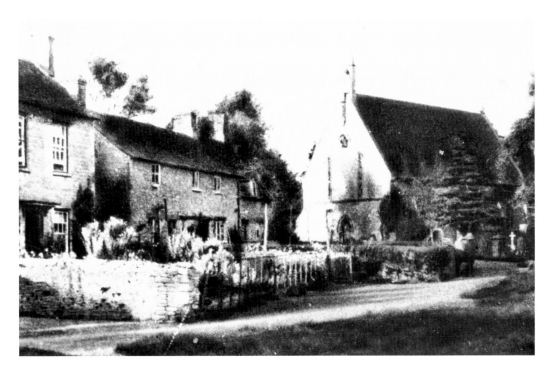

Wood Green

A picturesque scene on Wood Green, with the west gable of Holy Trinity Church visible to the right. As originally built, the church had featured a small and very slender turret, but this has now been replaced by a simple bell-cote as shown in the later photograph.

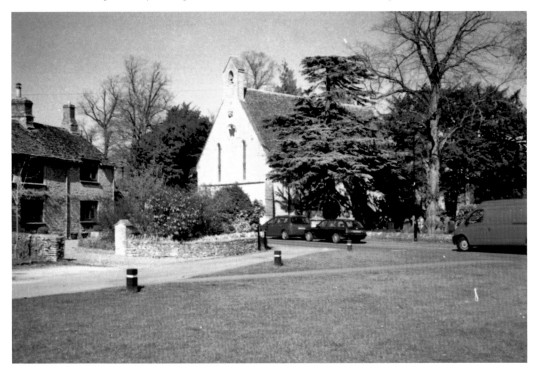

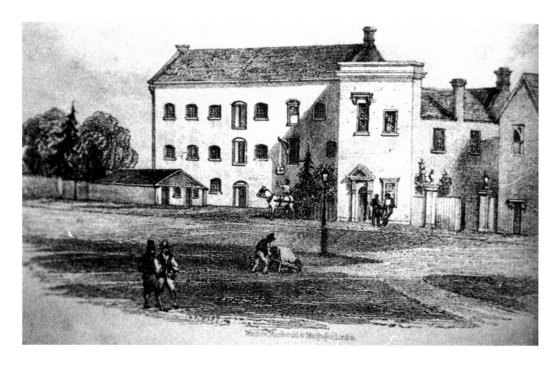

Woodgreen – Early's Blanket Factory

In 1840, Woodgreen Blanket Factory, on the east side of Woodgreen, comprised a 'house, outbuildings, weaving shops, gardens and yard'. The property was owned by John Early (1783–1862), the co-owner of New Mill, and a contemporary illustration suggests that the building was slightly taller than it is now, the roof having apparently been lowered during the Victorian period. By the late nineteenth century, the Woodgreen factory had been taken over by Charles William Early (1850–1943), but the venture was never prosperous and the building finished its industrial life as a joinery.

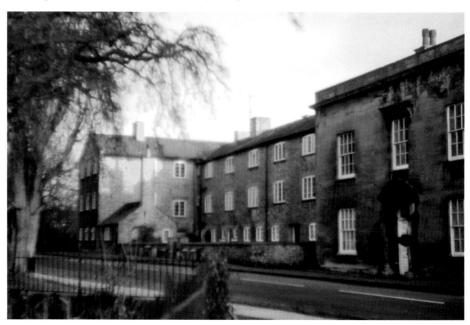

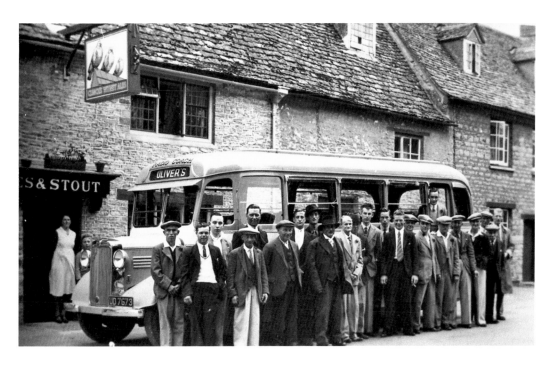

Woodgreen – The Three Pigeons

A pub outing about to depart from The Three Pigeons, no. 31 Woodgreen, probably *c.* 1938. Those present include Harry Green (extreme left), his son Reg. Green (third from left) and Lewis Langford (in coach), who seems to have been the driver and trip organiser. The lower photograph, taken in 2012, shows that The Three Pigeons has changed little over the years.

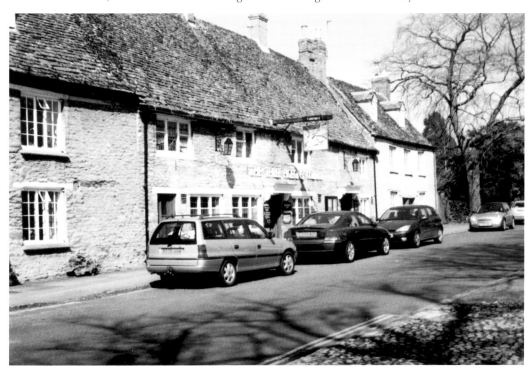

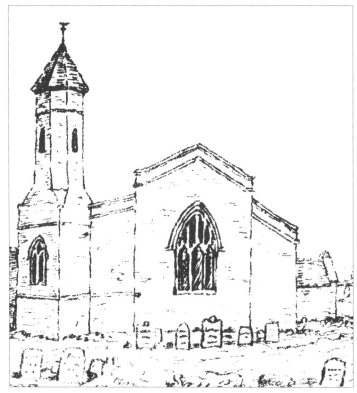

Newland

Although Cogges is now regarded as an integral part of Witney, in historical terms it was an entirely separate parish. The *Domesday Book* reveals that, in 1086, Cogges was held by a Norman called Wadard, although the estate later passed into the hands of another Norman family known as the d'Arsics, one of whom, Robert Arsic, laid-out 'Newland' as a planned township along the Witney to Oxford road. In the fullness of time, this new urban development became part of modern Witney – leaving Cogges Church, Priory and Manor Farm as a quaint and isolated group of old buildings on the edge of Witney.

Cogges Parish Church, dedicated to St Mary, was once associated with the monks of Fécamp Abbey, in Normandy, and this may explain the distinctly 'French' appearance of its unusual tower, which has octagonal upper stages and a pyramidal roof.

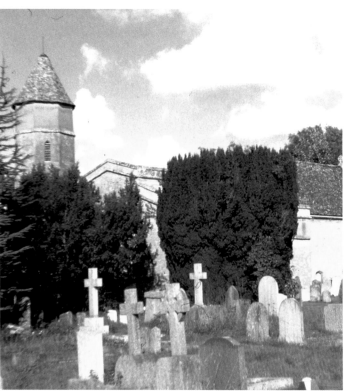

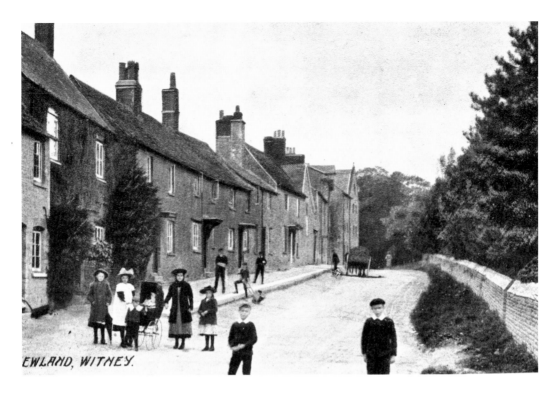

EWLAND, WITNEY.

Newland

These two photographs illustrate the western end of Newland, the upper one being a *c.* 1900 postcard view, while the lower one was taken in 2012. The tall, gabled building seen in the earlier view was Early's Newland Warehouse, which marked the boundary between Witney and Cogges. This fine Victorian structure was sold to a property developer in 1973 and mysteriously damaged by fire on 3 April 1975, after which new houses were built on the site.

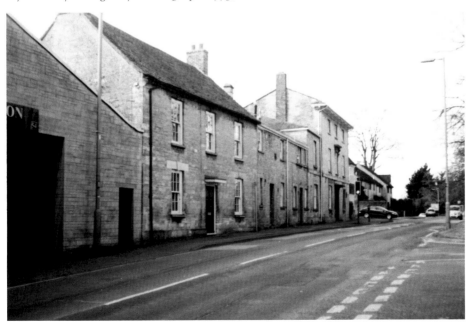

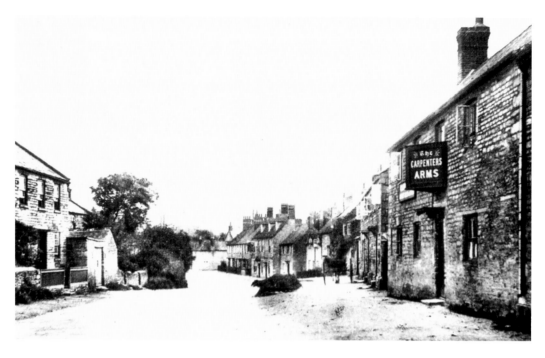

Newland – The Carpenter's Arms

Newland, looking east towards Oxford Hill, *c.* 1912 and in 2012. The Carpenter's Arms features prominently in both pictures, while the Griffin can be seen in the distance. Both of these local pubs are still extant.

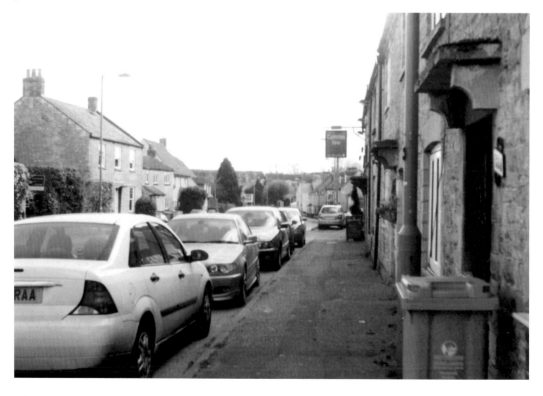

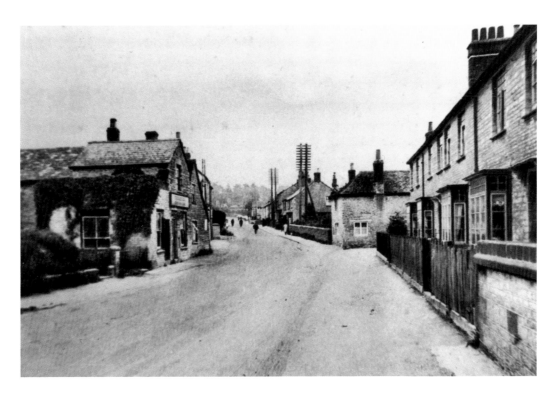

Newland – Looking East

As the road continues towards Oxford Hill, it curves slightly to the left and Church Lane converges from the right. The upper view shows the old turnpike house that formerly stood on the corner of Church Lane, while the lower view, which was photographed from a position slightly further to the east, shows the still-extant Griffin.

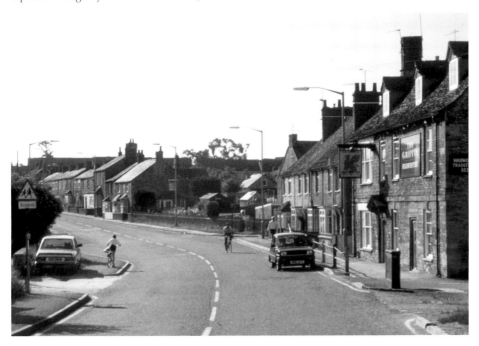

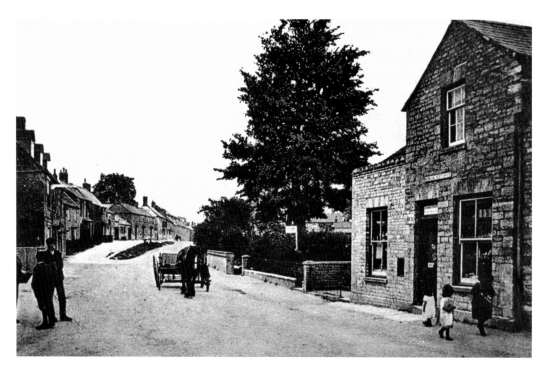

Newland – Looking West

Another view of Newland, this time looking west towards Bridge Street, with the Griffin visible to the left of both pictures. The building seen on the right in the earlier view was the Newland Sub post office.

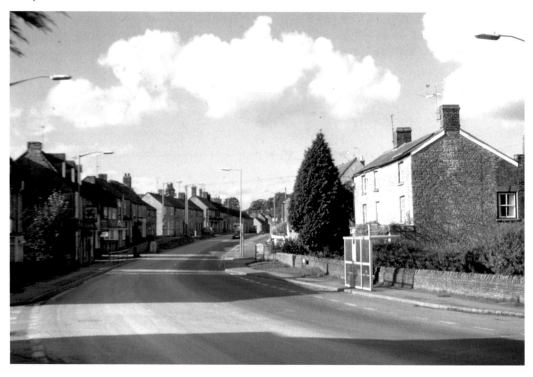

Newland – Oxford Hill

Oxford Hill, looking east towards Oxford, *c.* 1912. In those days, the Oxford road was little more than a country lane, the railway being Witney's primary transport link for both passengers and freight traffic. This is in marked contrast to today, when road traffic is incessant and the A40 is blocked by huge traffic jams as motorists struggle to get to and from Oxford during the morning and evening 'peaks'.

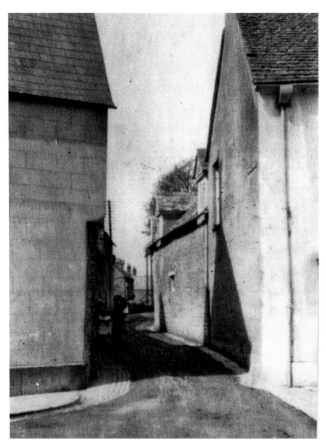

Mill Street – The Junction with High Street

The sepia photograph shows the narrow entrance at the eastern end of Mill Street, which was widened in 1909 when the buildings on the south side of the street were demolished. In that year, the *Witney Gazette* reported that the road-widening scheme was complete, and that traffic between London, Cheltenham and South Wales would be able to travel unimpeded along Mill Street and the Burford Road, rather than via High Street, Corn Street and Tower Hill.

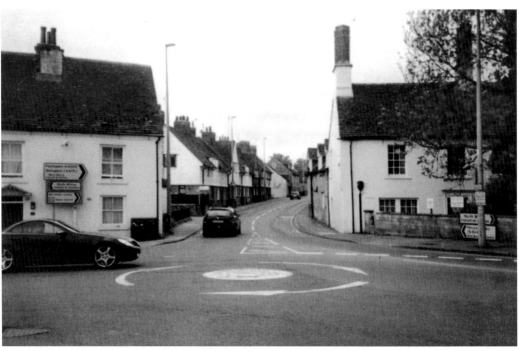

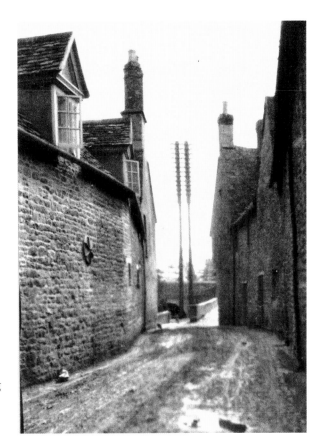

Mill Street

Another view of the exceedingly
narrow entrance to Mill Street
(right), looking east towards the
junction with High Street, with
the bridge just visible in the gap
between the houses. The modern
view (below) shows the widened
entrance. Until the construction of
Witney bypass, this modest-looking
road was part of the main A40
trunk route between London and
South Wales.

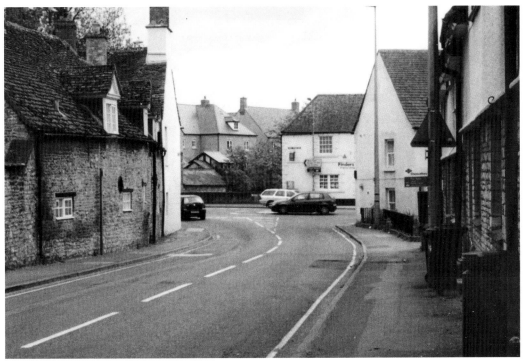

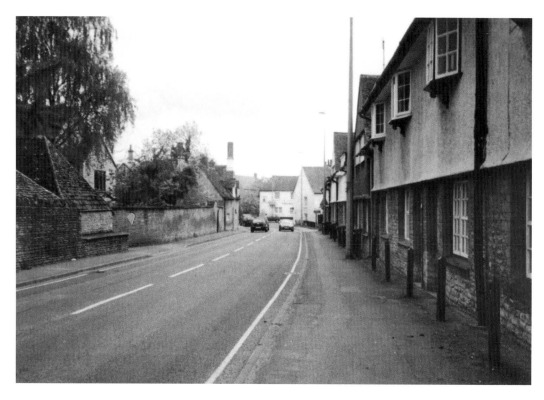

Mill Street

A recent view of Mill Street, looking east towards High Street and Witney Bridge. The 'vernacular revival' cottages visible to the right of the picture were erected as replacements for the demolished buildings on the west side of the lane. The earlier view (below) shows these buildings in greater detail.

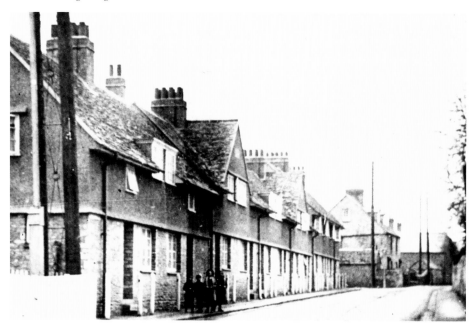

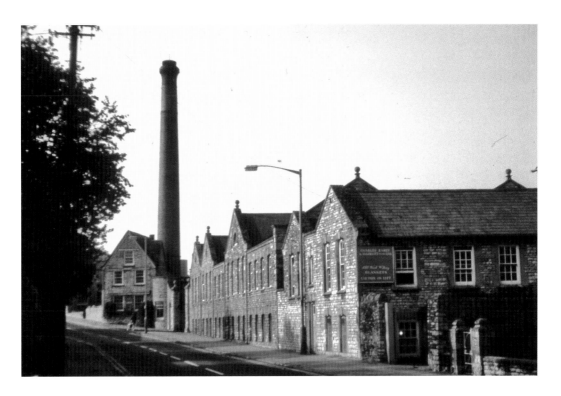

Mill Street – Witney Mill

Witney Mill was built on the site of a mill mentioned in the *Domesday Book*. It was recorded as a fulling mill in 1277, though in those distant times the site was known as Woodford or 'Waterford Mill'. The oldest building in existence dates from around 1820, while the attractive range of two-storey buildings adjacent to the road were erected by William Cantwell in 1888 and rebuilt after a fire in 1905. The 110 foot brick chimney dates from 1895.

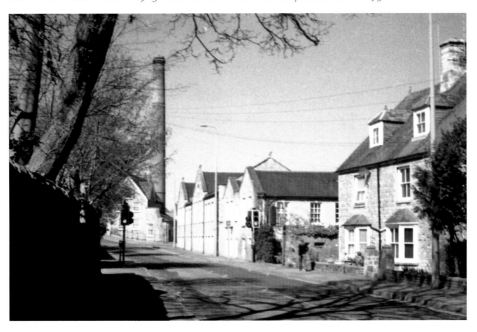

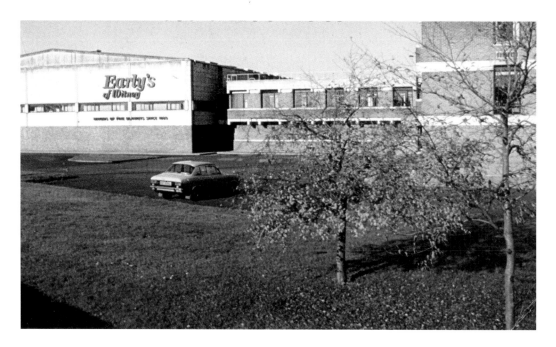

Mill Street – Witney Mill

Witney Mill eventually extended over both sides of Mill Street, a red brick spinning shed being erected on the south side of the road during the 1930s, while further expansion after the Second World War resulted in the provision of an enormous new factory to the west of the Victorian mill. This uncompromisingly modern building, which eventually superseded the older accommodation, was Witney's last working mill. It was officially closed on 19 July 2002, and the site is now occupied by new houses (below).

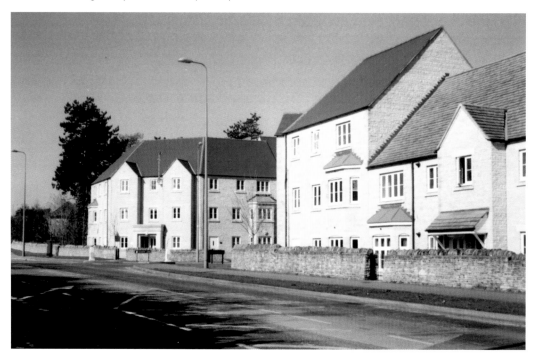

Burford Road – The Witney Mills Houses

In 1926, the 'Witney Mills Housing Society' provided twenty new houses on the north side of Burford Road, the new dwellings having been designed by A. S. De Vinney and built by Bartlett Brothers of Witney. Eight slightly-smaller houses were later built in nearby Springfield Park. Although intended initially for Early's employees, about half of the houses were leased to other tenants – possibly because very few of Early's workers could afford the weekly rent of 8*s* 6*d*.

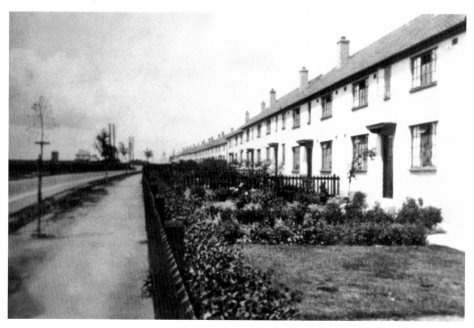

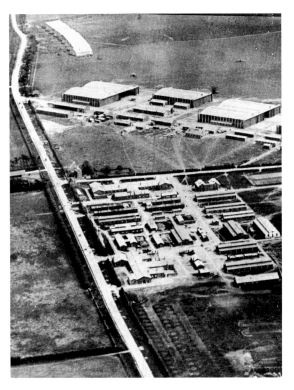

Burford Road – Witney Aerodrome & Smith's Factory

Witney Aerodrome was opened in 1918 and it was, from its inception, used for training pilots. The aerodrome boasted seven large hangars while, in addition, a line of canvas-covered Bessoneau hangars was erected to the west of the main hangar complex. As usual, during the Great War, there were no properly-surfaced runways; take off and landing operations were undertaken on a grass-covered landing area. The domestic site included a range of accommodation, including a guard room, hospital, officers' mess and airmen's barracks.

The aerodrome became a civilian flying school during the inter-war period, although all but one of its hangars was dismantled, leaving just one Belfast truss hangar *in situ*. The site was commandeered by the Air Ministry at the start of the Second World War and it was then taken over by de Havillands as a Civilian Repair Unit, although test flying continued from the grass landing area. In its new role, the airfield provided employment for over 1,200 people, with planes being flown in for repair by female transport pilots, or brought onto the site in 'Queen Mary' transporter vehicles. In total, the Witney CRU repaired over 700 Hurricanes and Spitfires, together with around 800 de Havilland aircraft, including Mosquitoes, Tiger Moths and Rapides.

In 1951, Smith's Industries Ltd established a large engineering factory on the site of the former aerodrome, which had been closed in 1949. By the 1960s this firm, which manufactured vehicle heaters and hydraulic equipment, was employing as many as 1,500 people. However, the vehicle heater section was closed in 1988, while the Hydraulics Division succumbed in 2001, and the once-thriving Burford Road factory has now been split-up into small industrial units.

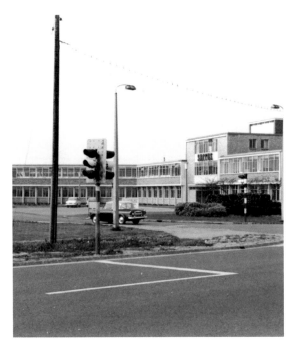

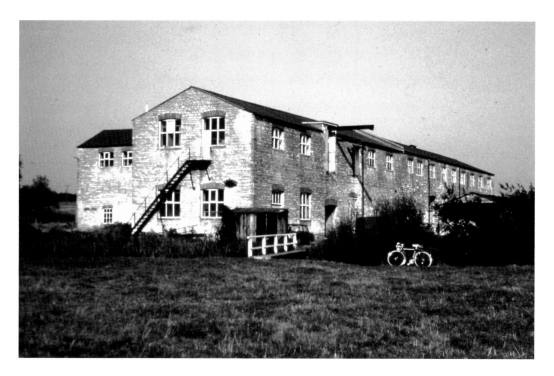

The River Windrush – New Mill

The blanket industry relied on the Windrush for many years, with mills such as New Mill being sited at regular intervals along the river, so that water power could be effectively utilised. In the 1850s, New Mill was shared by John Early and Edward Early, while in the 1880s the mill was being used by Charles Early and his relatives Messrs Thomas & Walter Early. The mill fell into disuse during the 1950s and the buildings were subsequently adapted for other uses.

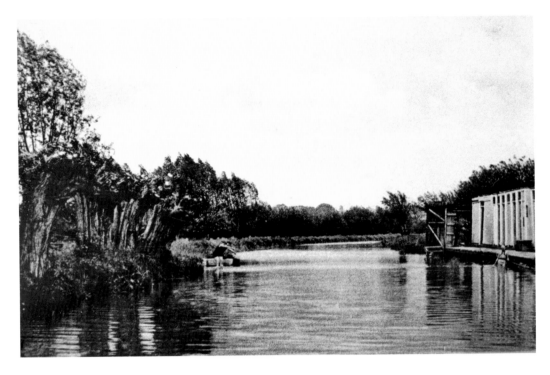

The River Windrush – The Bathing Place

Sited downstream from New Mill, the 'Bathing Place' consisted of a fenced-off section of the river, which was equipped with diving boards and a row of primitive huts that masqueraded as changing rooms. Pre-war editions of *The Witney Official Guide* refer to 'a fine open-air swimming pool in the River Windrush, which is well-patronised throughout the summer'. This amenity was said to be 'beautifully situated', with 'splendid accommodation for both sexes in the way of cubicles'.

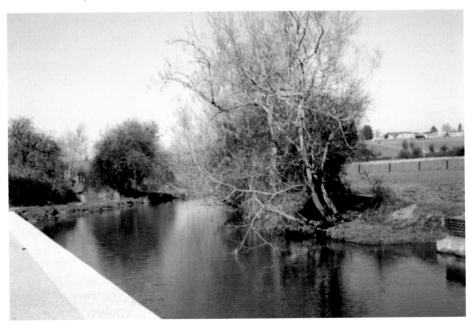

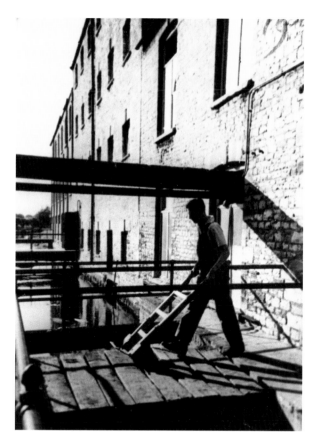

The River Windrush – Witney Mill
As mentioned earlier, Witney Mill
was closed in 2002, but the site
was subsequently re-developed,
the new factory being replaced by
a housing estate, while many of
the older buildings were adapted
for residential use. A number of
waterside apartments were built
alongside the tail-race, as shown in
the lower photograph.

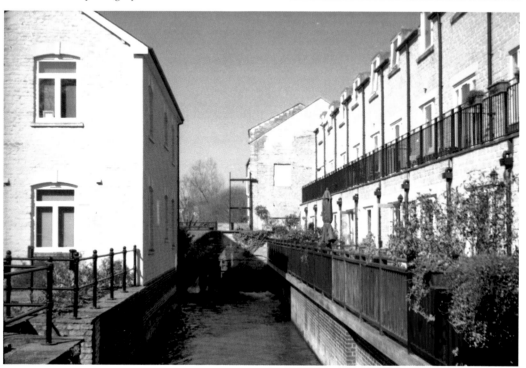

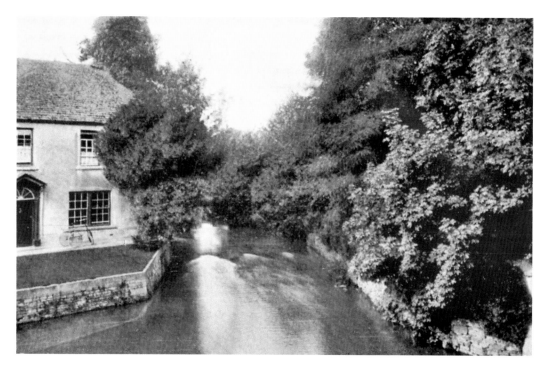

The River Windrush – A View From The Bridge

An attractive scene, looking upstream from Witney Bridge, *c.* 1900. The flow of water was, at that time, restricted by the narrow apertures of a triple-arched bridge, resulting in the formation of a gravel 'beach' in front of the seventeenth-century house which enabled horses to drink from the river. The bridge was rebuilt in 1926 (see p. 50) and the 'beach' has disappeared, but the seventeenth-century house remains and has been refurbished following flood damage in 2007.

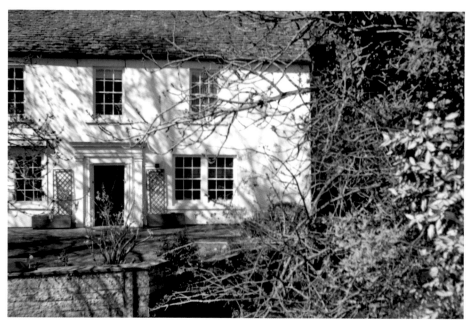

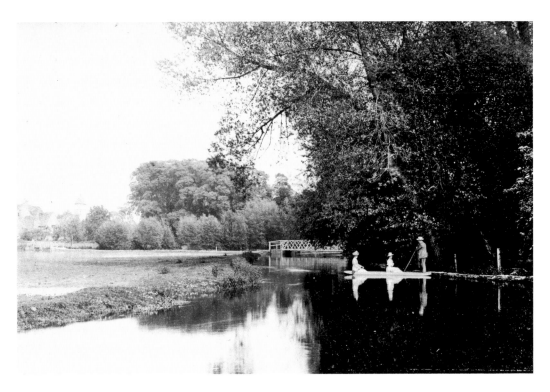

The River Windrush – Langal Common

Having passed beneath Witney Bridge, the river splits into two streams, the grass-covered open space between the two channels being known as Langal or 'Langle' Common. In Edwardian days, the gardens of the shops and houses on the east side of High Street extended down to the river bank and some householders kept skiffs or punts for use during the summer months.

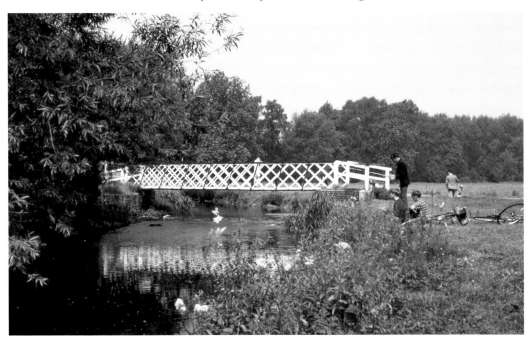

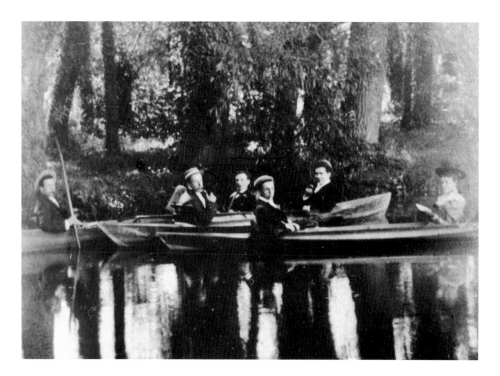

The River Windrush – Edwardians Afloat

Another idyllic scene showing a group of Edwardians relaxing on the western branch of the Windrush in the halcyon days before the First World War. The lower picture, in contrast, shows that routine maintenance of the river has been sadly neglected in recent years, the streams and watercourses being choked with weeds and fallen trees – factors which are thought to have contributed to severe flooding which took place in Witney in July 2007, when over 200 properties were inundated.

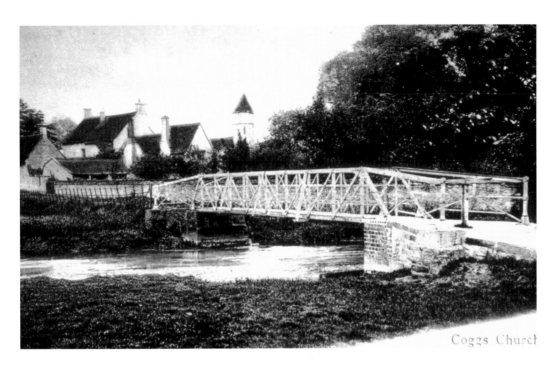

Coggs Churck

The River Windrush – The Eastern Stream

Crown Lane crosses Langal Common at right angles, necessitating footbridges across both branches of the river. The upper view is an Edwardian postcard depicting Cogges Church and the eastern bridge, while the lower picture is a recent photograph showing the eastern stream from Cogges Bridge. Two 'Norcon' pattern concrete pill-boxes, dating from 1940, can be seen among the pollarded willows – though it is hard to imagine what use these would have been if the Germans had invaded!

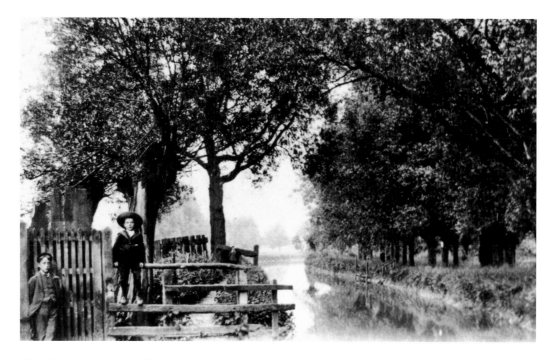

The River Windrush – The Western Stream

Looking south along the western stream *c.* 1912 (above), and a century later (below). The footbridge which can be seen in both photographs spans a small side-channel. The name 'Windrush', as a matter of interest, is thought to have been de=rived from *Gwen-risc,* a Celtic river name signifying the white stream or morass – a reference, perhaps, to abundant white flowers which may once have bloomed along its banks.

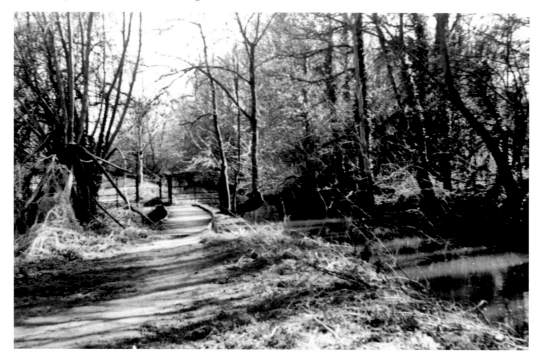

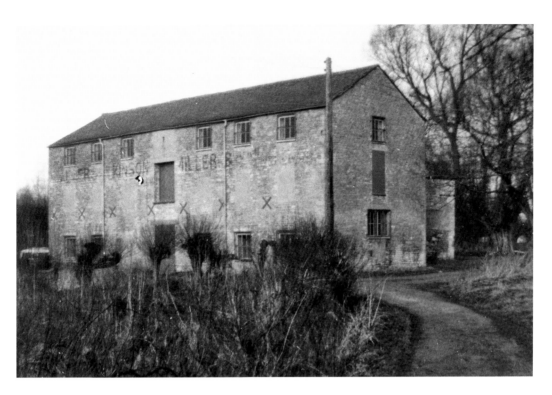

The River Windrush – Farm Mill

Farm Mill, which spans the western stream and occupies the site of the much earlier 'Walleys Mill', is a typical three-storey water mill, built across the mill stream in the usual way. It was at one time an L-shaped structure with an extension at the western end and a projecting wing beside the head-race. In 1852, Farm Mill was being used for blanket-making by Edward Early, although by 1916, the occupants were Messrs Walker & Atkinson, corn millers.

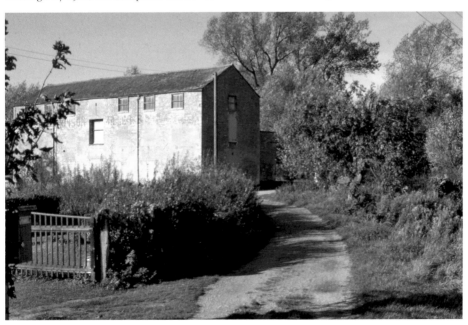

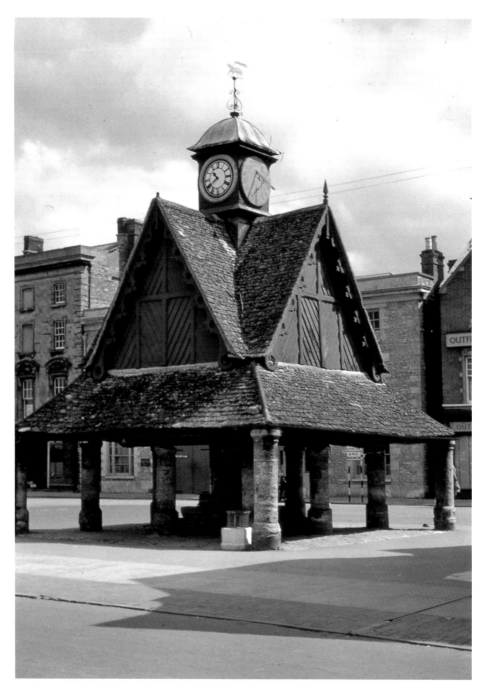

The Buttercross

A final view of the famous Witney Buttercross, taken in 1956, before demolition of the handsome, Georgian-style buildings on the east side of Market Square. At that time, the Buttercross featured ornate timber gables, but these were subsequently replaced by plain, rendered gables.